READ THIS IF YOU WANT TO TAKE GREAT PHOTOGRAPHS OF PLACES.

D1376586

LAURENCE KING

Published in 2017 by
Laurence King Publishing Ltd
361–373 City Road
London EC1V 1LR
e-mail: enquiries@laurenceking.com
www.laurenceking.com

© text 2017 Henry Carroll

This book was designed and produced by
Laurence King Publishing Ltd, London.

Henry Carroll has asserted his right under
the Copyright, Designs and Patents Act, 1988,
to be identified as the author of this work.

A catalogue record for this book
is available from the British Library.
ISBN: 978-1-78067-905-1

Picture research: Peter Kent
Illustrations: Carolyn Hewitson

Printed in China

READ THIS IF YOU WANT TO TAKE GREAT PHOTOGRAPHS OF PLACES.

HENRY CARROLL

Where are you?

Look around for a minute. If you were to take a picture that captures your thoughts and feelings about where you are right now, what would it be? Tricky, isn't it, but perhaps this will help.

Taking great photographs of places is all about what, when and how.

'What' kind of places stir your ideas or emotions – wilderness areas, industrial scenes, places with historical significance? 'When' would you want to photograph them – early morning, during the day, at twilight or in the dead of night? 'How' do you want to photograph them – deep or shallow focus, wide or telephoto lens, a classic composition or something more unorthodox? Marry these three elements together and your photographs will be elevated into something with meaning.

This is sometimes a subconscious process because you're acting on instinct. Other times it's more considered because you're visualizing a specific, preconceived concept. When looking at the 50 pictures here, try to keep in mind the 'what, when and how' that led the masters to their end result. Doing that will start you down a road leading to the places that mean something to you.

Understanding the processes behind the pictures and having just a little technical know-how is important, too. So if you're totally new to photography I recommend first reading *Read This If You Want To Take Great Photographs*. That will give you a solid grasp of the basic techniques, while this book shows you how to apply them creatively to photographing places.

As always, we won't dwell too much on the techie stuff, because with photography a little of all that goes a long way. There's something far more important to consider first and that's exactly where we're going to start.

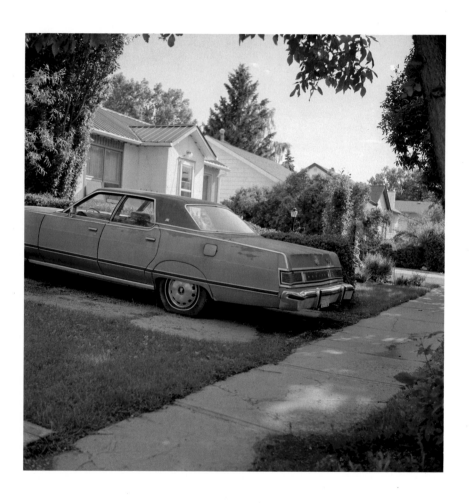

Population 477
from the series 'Out West'
Kyler Zeleny
2012

Where do you stand?

Composition. It's all about finding order in what might initially seem like chaos. It's about filtering information with your eyes. It's about simplifying what you see and distilling everything down into a single, coherent frame.

Classic compositional techniques like leading lines, foreground interest, symmetry and the rule of thirds (which I'm sure you know) are all-important when photographing places, but often these 'solutions' aren't immediately obvious when eyeing up a scene.

Really, it all comes down to two things: your left foot and your right foot.

Kyler Zeleny knows exactly where to stand. By taking the time to find precisely the right spot, he finds absolute order within his frame. Every part of this composition is working together, elevating a nondescript driveway into a beautifully balanced arrangement of lines and colour.

You might need to move miles, or simply step to the left or right, because when photographing places, your physical position has a huge impact on *meaning*. That's why all the photographers in this book are obsessively picky about where they stand. To join their ranks, you need to be the same.

COMPOSITION

Solid foundations

For other examples:
Kyler Zeleny p.8
Mitch Dobrowner p.19
Reiner Riedler p.96

If the City of Angels did ever have any angels, then they are pictured here in Julius Shulman's iconic photograph of Stahl House.

This is a photograph that captures a sense of place exquisitely. Illuminated against the night, the modernist architecture elevates these women from the valley of broken dreams below. As they sit there, engaging in idle conversation, everything seems right with the world. Everything is at peace.

Let your eyes lead you to the right spot.

Shulman's position draws out the lines in the scene, which lead us into the image to create a kind of visual narrative. In the foreground the lines of a sun lounger lead us up to the house. Even the placement of the cushion acts like a discreet pointed finger. Then the architecture guides us inwards to the women, before the canopy escorts us outwards again, along the boulevards of Los Angeles, all the way to the horizon.

From the foreground to the background, always look for the leading lines. They can be subtle or overt, but without an underlying structure to your composition, the viewer will be lost.

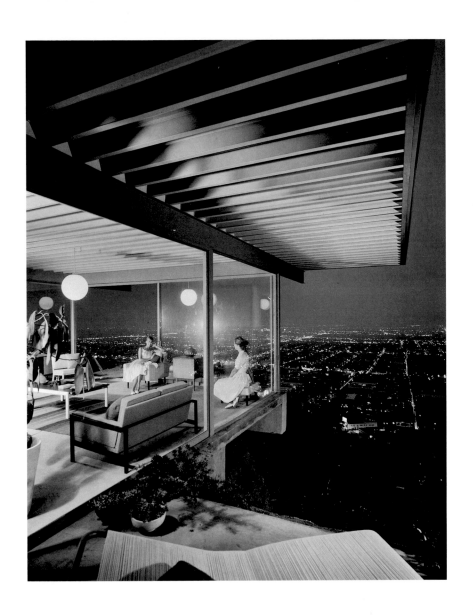

Case Study House #22,
Pierre Koenig, Architect
Julius Shulman
1960

Simple Present #549,
Hong Kong
Bert Danckaert
2011

Cream of the crop

There's nothing remarkable about Bert Danckaert's subject, yet the exactitude of his framing transforms this humdrum scene into a humdinger.

Imagine if those lines were not exactly vertical and horizontal in relation to the edge of the frame. Imagine if that tiny section of green was not in the bottom left corner. Imagine if we could see more of the surrounding environment. It would all fall apart, wouldn't it?

You are a surgeon and your camera a scalpel.

A sloppy frame will render even the most striking subjects banal, while a precise frame can elevate nothing into everything. Danckaert's attention to every inch of his frame, and awareness of what should and shouldn't be included, lead to an image that holds its own alongside any abstract masterpiece.

The photographic frame requires you to have absolute confidence. This is your opportunity to show us what you find most important. Convince us with your cut.

For other examples:
Tim Hetherington p.15
Yoshinori Mizutani p.28

Pictures in pictures

For other examples:
Julius Shulman p.11
Rinko Kawauchi p.44

Here the late Tim Hetherington has photographed an abandoned hospital in war-torn Liberia. The room, once intended for saving lives, now stands as a bombed-out shell. Through the window we see a landscape so dense with lush green vegetation it appears like the promised land.

The contrast between the two environments is intensely palpable. Rather than accept its place in the background, this restless frame-within-a-frame forces itself forward and seemingly hovers in space. This effect is also helped by the deep depth of field (see p. 50).

Use framing to communicate the story of a place.

Framing is mostly used as a technique to isolate a subject within a wider composition. But if you look at Hetherington's photograph, you'll see that there is no singular subject. The beauty comes from the composition as a whole and the oscillation between the foreground and background. Two opposing states, one symbolizing death and the other life.

Isn't it amazing how so much can be said with such a simple compositional device?

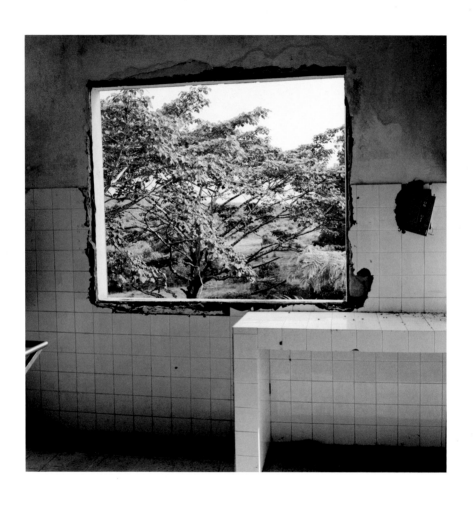

Tubmanburg, Liberia
Tim Hetherington
2003

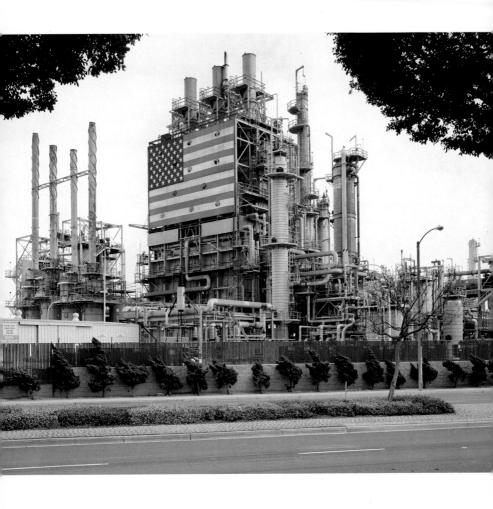

*BP Carson Refinery,
California*
Mitch Epstein
2007

Side effects

For his series 'American Power', Mitch Epstein turned his eye to symbols of production, consumption and surveillance within the United States, the world's second largest polluter.

This oil refinery emblazoned with the Stars and Stripes stands proud, unashamed of its environmental impact. By photographing the structure at an angle, Epstein highlights its cuboid form and creates order from a labyrinthine system of pipes, funnels and metal framework. This three-dimensionality lends his subject an air of power and permanence.

Shooting a subject at 45 degrees draws out its three-dimensional qualities.

The more sides you show of a subject, the greater its sense of form. That's because perspective comes into play as our eyes travel from near to far along the diminishing lines of each surface. Look back to page 12 and you'll see how the opposite is true when shooting something front on.

Man-made structures, like buildings, tend to be quite blocky, so position yourself opposite one corner and your view of two sides will be equal. Natural formations, like rocks, are more irregular, but they still have a best side. It's just a case of finding the position that best draws out their three-dimensionality.

For other examples:
Kyler Zeleny p.8
Julius Shulman p.11
Mike Slack p.92
John Davies p.100

Heaven and earth

For other examples:
Massimo Vitali p.20
Richard Misrach p.52
Fay Godwin p.103

Storm chaser Mitch Dobrowner photographs the extreme weather that rolls across the pastures of the Midwest. Here, with almost all his composition given over to the sublime sky, it's hard to imagine that this force of nature will, at some point, dissipate. For now, those apocalyptic clouds are unstoppable and the landscape below appears totally vulnerable.

Deciding where to place your horizon is both a compositional and conceptual choice.

There really are no rules when it comes to positioning your horizon. That doesn't make it unimportant, though, because the position of the horizon changes everything. It's all about emphasis.

Big skies tend to make us respond emotionally because the composition is dominated by something out of our control. This can fill us with anything from a sense of foreboding to freedom. Images dominated by large expanses of land, on the other hand, which are often dotted with man-made features, are more likely to trigger social and political references.

By positioning the horizon so low, Dobrowner's skies become overbearing, reminding us of our own insignificance.

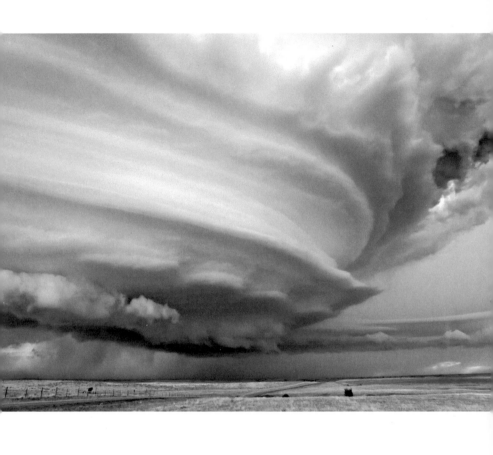

Chromosphere,
Green Grass, South Dakota
Mitch Dobrowner
2007

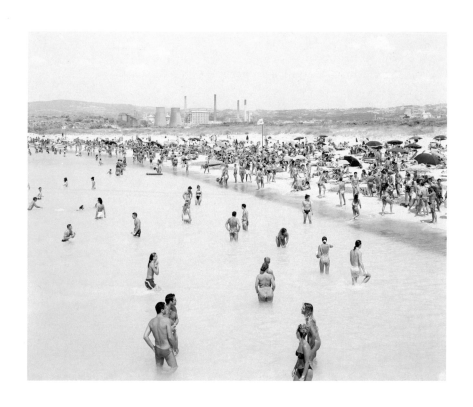

Rosignano Culona
Massimo Vitali
1995

High and mighty

Italian-born Massimo Vitali is well accustomed to the realities of Mediterranean beaches. People flock to the chalky white sands and clear blue waters only to find that their beach paradise is more densely populated than the city they are trying to escape.

Vitali often photographs these overcrowded playgrounds from the top of a scaffold tower that he builds in the water. This elevated point of view creates order and allows him, and us, to make sense of the scene in its entirety. Here it means that the juxtaposition of the power station and the beach is impossible for us to ignore. Yet, from ground level, the bathers' understanding of the environment is limited to the bronzed bodies immediately surrounding them.

An elevated point of view physically and emotionally separates you from the world.

When you're up high and looking down on the world you offer the viewer a more privileged perspective. It's similar to the cinematic convention of the establishing shot, which movie makers use to introduce a location in a factual manner before cutting to the action.

In compositions like these, foreground – or the lack of it – plays a key role. Here there is no immediate foreground, which would offer us a physical explanation as to Vitali's position. As a result, his viewpoint feels all the more removed. In the context of this image he is floating in the air, completely detached from the world below.

For other examples:
Yoshinori Mizutani p.28

In the mix

For other examples:
Lee Friedlander p.27

In contrast to the previous example, here Joel Meyerowitz shoots at ground level. His photograph depicts New York as a confusion of people, signs and high-rise buildings. If there is a subject, it's that fleeting exchange of goods in the foreground – theatre tickets perhaps?

When you are part of the scene, so is the viewer.

Meyerowitz's style is unlike traditional street photography, which tends to home in on a singular subject. For him, people and place are inseparable, and here both elements share equal importance within the frame.

When photographing cities, the transient flow of people is as much a part of the environment as the more permanent features. So rather than pretend the people don't exist, choose your spot carefully and make them an integral part of your composition.

New York City
Joel Meyerowitz
1976

Take a step back

As night falls over the United States, lights appear on the horizon. They could be from small towns or sports stadiums, but the lights in Stephen Tourlentes' photographs come from penitentiaries.

This illuminated structure housing a community of inmates – some waiting for parole, others waiting to die – lingers menacingly in the distance. The subject's smallness compared to the vast space around it highlights its isolation and becomes a potent metaphor for a political system that prefers to ostracize citizens rather than rehabilitate them.

Subjects don't have to fill the frame to pack a punch.

By allowing your subject to sit within a wider composition you communicate context. This makes the viewer aware of the landscape the subject exists within. Just keep in mind that if your subject is small within the composition, you need to make sure it still remains the focal point. Tourlentes photographs at night, meaning we're instantly drawn to the cluster of lights. Alternatively, good old-fashioned leading lines will do the job.

For other examples:
William Henry Jackson p.86
Charles Duke p.118

Wyoming Death House, Rawlins, WY
Stephen Tourlentes
2000

Wide boy

For other examples:
Olaf Otto Becker p.40
William Henry Jackson p.86

When Lee Friedlander drove across the United States, he didn't even get out of the car to take pictures. Down city streets, alongside railroad tracks, across desert plains and over mountains, he simply shot what he encountered through the windows.

This results in the interior of the car becoming an all-important piece of 'foreground interest'. The upholstered lines suck us into the composition from all directions and frame the landscape, making his series as much about the car as the changing scenes beyond.

Wide-angle lenses exaggerate 'foreground interest'.

Wide-angle lenses (those with short focal lengths) take in a wider field of view. The foreground appears stretched, and distant subjects look smaller and further away. Often compositions can feel a bit too 'roomy' when photographed with a wide lens, so use foreground elements to add structure and lead the viewer's eye.

More than just a practical decision, Friedlander's choice of lens unlocked a new point of view, both physical and conceptual, enabling him to make a humorous homage to the great American road trip.

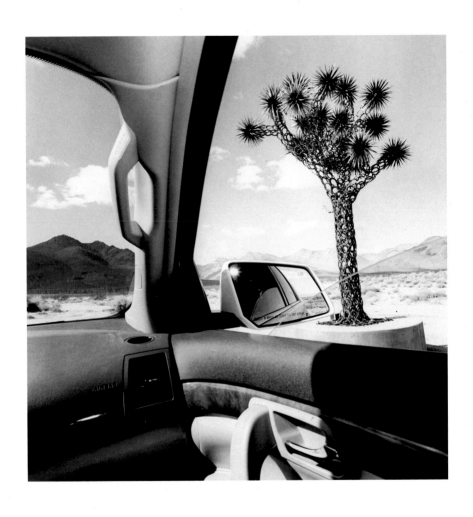

California
from the series 'America by Car'
Lee Friedlander
2008

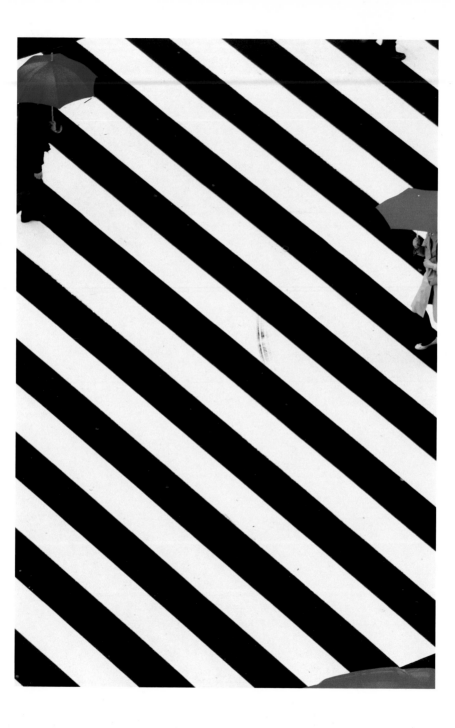

The world is flat

His tool of trade may be a camera, but here Yoshinori Mizutani comes across more like a graphic designer than a photographer.

It's raining and the umbrellas are out in this playful composition. Against the strong black-and-white lines of a street crossing in Tokyo, three flashes of colour – red, green and blue – enter the frame. Their placement is so random, but linger on the image a little longer and you realize that the usual rules somehow don't apply and everything is exactly where it should be.

The rules of composition can change when using a telephoto lens.

The downward angle of view, combined with a telephoto lens, makes this scene look entirely flat. Such lenses offer a very tight field of view, similar to peering through the eyepiece of a rifle. The perception of distance and depth is lessened and everything appears to sit on the same plane.

This flattening of space means that compositional techniques like leading lines and foreground interest, which are used to guide the eye 'into' an image, become less relevant. Instead, the eye stays on the surface, meaning you need to pay more attention to creating balance through the placement of colour, tone, line and shape.

For other examples:
Fay Godwin p.103

Rain
Yoshinori Mizutani
2015

Format

It might seem too obvious even to mention, but the impact of format is something that so many of us take for granted. If a picture is portrait format, our eyes are encouraged to move vertically. If a picture is landscape format, our eyes move horizontally.

Portrait format

Portrait format tends to make the most of foreground interest because the vertical frame allows you to include more of what's right in front of you (see p. 11 and p. 95), especially if you're using a wide-angle lens. This heightens the sense of perspective, as the viewer's eyes follow diminishing leading lines from the bottom of the image to the top.

Landscape format

The horizontal nature of landscape format tends to emphasize the horizon. The horizontal frame also creates lots of space to the left and right of your subject. Use the rule of thirds to make better use of the frame and maintain balance. This also encourages the viewer's eye to move in a controlled way across the image.

Aspect ratio

Aspect ratio refers to the shape of your frame and the relationship between its length and width. Here is a summary of the most common aspect ratios and when they are best applied.

3:2

This follows the classic proportions of 35mm film, and more or less those of full-frame and APS-C sensors. Even though 3:2 is one of the most familiar aspect ratios, it can feel awkwardly long when shooting portrait format. This is why many landscape photographers prefer a slightly shorter rectangle.

4:3

This is common in many compact-system cameras and closer to the proportions of large format view cameras, which are traditionally used for landscape photography. It's still a rectangle, but the proportions are slightly shorter. This tends to mean that subjects fill more of the frame, with less risk of excess space. There's still a natural horizontal or vertical flow, but less so than 3:2.

1:1

Most digital cameras and smart phones have a 1:1 option. As a square doesn't have a natural horizontal or vertical flow, this aspect ratio requires a slightly different way of working. Composition alone dictates the movement of the viewer's eye, whether that's vertical, horizontal or circular.

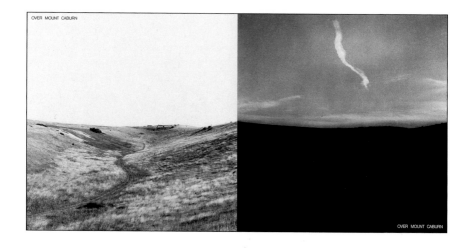

Over Mount Caburn
John Hilliard
1978

Time and space

Exposure isn't just a technical exercise in adjusting strange-sounding numbers. It's a way of freeing up your creativity and taking control of your pictures so they look exactly the way you want.

Remember the 'what, when and how'? Well, exposure is a big part of the 'how', because the choices you make completely alter how the viewer 'reads' your image. Shutter speed, whether fast or slow, affects our sense of time, while aperture and depth of field affect our sense of space.

Exposure alters the viewer's perception of a place.

Here John Hilliard takes two pictures of the same landscape. Neither the subject matter nor the composition has changed from one picture to the next, yet the change in exposure makes the images starkly different. In one a path meanders its way through the grass under a white sky. In the other, a vapour trail cuts a strangely similar line through the sky over a black landscape.

Hilliard photographs photography. In other words, he plays with the visual traits unique to the medium to affect our perception of a subject. This diptych is a reminder that when it comes to representation, exposure is less a case of right and wrong, and much more about creative choices.

Movement and stillness

For other examples:
Charles March p.36

What was once an apartment building is now a slumped shell that's succumbed to the violence of war. In front of it a shepherd stands still, just for a moment, and looks directly into the camera. And in front of him a river of livestock washes past, from left to right, taking us into an uncertain future.

Here Simon Norfolk compresses past (the building), present (the shepherd) and future (the livestock) in a single frame. By contrasting movement and stillness, this photograph of a crumbled Kabul reminds us that no one can change the past, no one can predict the future and, even during times of war, life goes on.

Slow shutter speeds capture a sense of time passing.

Because the shutter stays open for longer, subjects have time to move during exposure. This creates blur. However, you'll also risk flooding your camera with light, so compensate by using a smaller aperture. That said, if you're shooting in very bright daylight you may find that your picture is still overexposed. In such situations, you only have one choice.

A neutral-density filter, or ND filter, limits the amount of light coming into your camera (see p. 73). This grey piece of glass or plastic is a bit like putting sunglasses over your lens. As a result, you can use slower shutter speeds in brighter conditions, as Norfolk has done here.

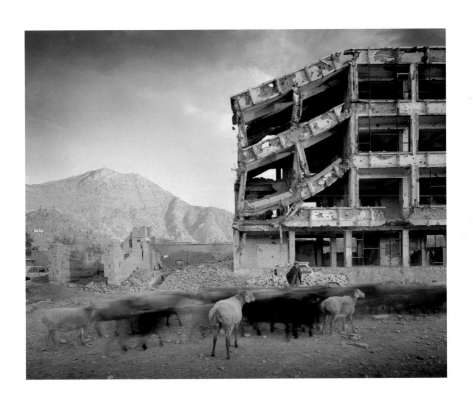

Karte Char, Kabul
from the series
'Afghanistan: chronotopia'
Simon Norfolk
2002

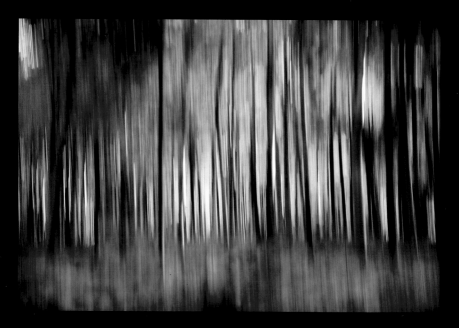

Molecomb Peak
from the series 'Wood Land'
Charles March
2014

Speed freak

Charles March, the man behind two of the UK's largest motor-racing festivals, is also a photographer, and he likes his cars fast and his cameras slow.

March photographs woodland scenes mostly around his home. In an attempt to capture the imposing verticality and density of the trees, he abstracts what he sees by moving the camera during a long exposure. Here, over a second or so, the camera follows the lines of the trees, resulting in marks that look more like the work of a brush than light.

Photography doesn't need to be tied to representation.

Even when using slow shutter speeds, most photographers retain some degree of detail to show what somewhere looks like. But when you abandon this idea and distance yourself from literal representation, photography edges towards something more undefined and gestural.

March's approach to landscape photography is unorthodox. He isn't lining up his shot and pressing the shutter while holding his breath so everything is pin sharp. He's looking at his subject and moving his body in response to the lines. I suppose he's engaging in a kind of dance with photography itself.

Right here.
Right now.

Photography duo Floto + Warner use non-toxic coloured liquids to inject an element of spontaneous beauty into the lifeless landscape of the Nevada Desert.

With photography, what goes up does not have to come down. When frozen with a fast shutter speed of around 1/3200, the green liquid appears solid and organic, like some peculiar cactus growing out of the desert floor. This abstract oddity, impossible to discern with the naked eye, is something only made visible through the magic of photography.

Fast shutter speeds arrest time and arrest attention.

The reason for choosing the Nevada Desert was both conceptual and technical. The barren stillness of the landscape makes this formation all the more expressive, and without any distracting environmental details, the graceful lines and delicate droplets of the water become more apparent. And then there's the intensity of the bright desert sunlight. This allowed the duo to use fast shutter speeds to freeze movement, along with narrow apertures to create a deep depth of field.

We've seen how shutter speed can affect 'time'.
Now let's see how aperture can affect 'space'.

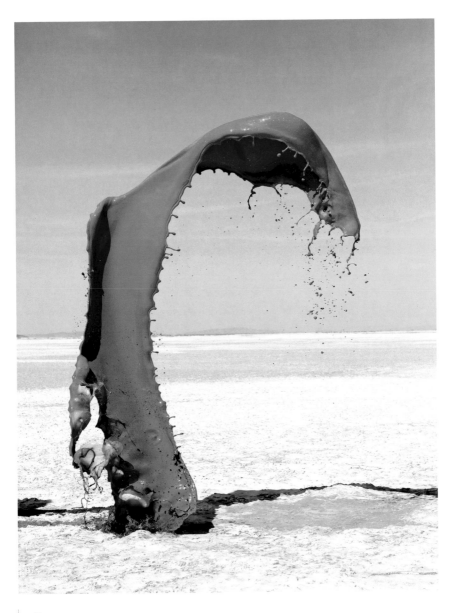

Green
from the series 'Colourant'
Floto + Warner
2014

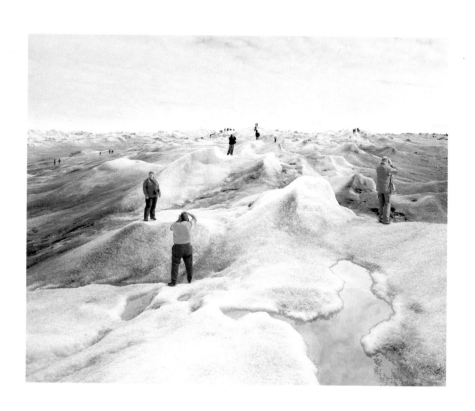

Point 660, 2, 08–2008
Olaf Otto Becker

Deep impact

In the foreground of Olaf Otto Becker's photograph, the man in the blue shirt and chinos looks strangely out of place. It's like he's stepped out briefly during his lunch hour to photograph his companion on an ice sheet. Then, as your eyes venture further into the distance, you notice that this vast frozen landscape is teeming with people, all equally out of place, just standing, walking and gawping.

For other examples:
Julius Shulman p.11
Lee Friedlander p.27
Robert Adams p.59
Ansel Adams p.95

Big 'f-number' means big area of focus. Small 'f-number' means small area of focus.

Becker is a landscape photographer who quite literally brings the effects of climate change sharply into focus. He uses a small aperture (big f-number) to create a deep depth of field. This clarity helps to communicate the scale and detail of the landscape, as everything from the very foreground through to the very background is pin sharp.

Just a word of warning, a small aperture limits the amount of light that enters the camera. This means that, even on a bright day, you'll need to compensate with a slower shutter speed. So, to avoid camera shake, have your tripod handy.

The small things

It's a discarded bottle, by the side of a pond, in a wooded area, on the outskirts of a city. John Gossage has the world to photograph, so why would he draw our attention to this?

For his series 'The Pond', Gossage presents us with an authentic experience of nature. By 'nature', I don't mean the wilderness areas celebrated by Ansel Adams, which are less accessible to those of us living in cities. I mean those patches of unkempt land existing somewhere in between. Those places that offer us a taste of the wild, but ultimately fail to satisfy what we're looking for.

A shallow depth of field communicates an intimate connection with a place.

If a deep depth of field communicates scale and vastness, a shallow depth of field (wide aperture / low f-number) does the opposite. Using focus to draw the viewer's eye to a specific detail within the landscape implies that you're taking a closer look at the world. It highlights the subjects that are so often unseen.

Focus is one of those things that most people treat as purely practical. But depth of field, especially when shallow, is a powerful photographic device. Arbitrary it ain't, because the subject you choose to focus on, no matter how seemingly unimportant, causes the viewer to reflect on its significance.

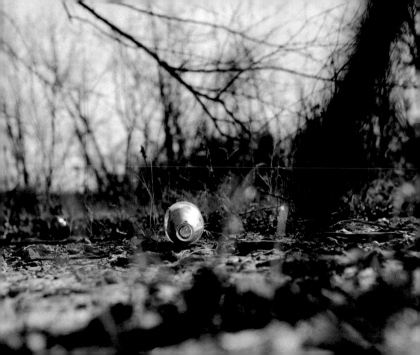

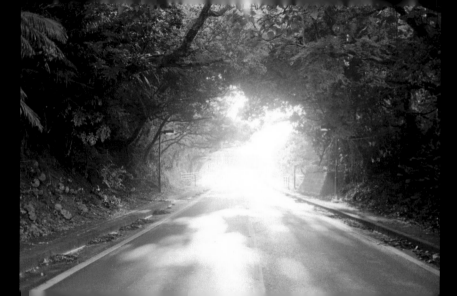

See the light

Rinko Kawauchi elevates everyday places and encounters into something extraordinary through composition and exposure.

Here Kawauchi photographs a wooded road that leads us into an oblivion of white light. Overexposed, the light becomes mesmerizing and you can't help being seduced by its brilliance. Like an unexplainable spiritual encounter, Kawauchi's treatment of the light prompts us to contemplate life's journey and the inevitable end that, one day, will confront us all.

For other examples:
John Hilliard p.32

Overexposing carries with it a sense of revelation.

Mesmerizing it may be, but we all know what's going on. The late afternoon sun is streaming through the trees, creating a stark contrast between the highlights and the shadows. By overexposing, Kawauchi draws out the details in the trees while completely burning out the sunlight. This can be done with Exposure Compensation ⊠ by scrolling towards the **+**.

Old-timers will tell you that burnt-out areas are bad because all visual information is lost, but Kawauchi puts that theory to bed. Her approach is more about feeling the light and responding instinctively to what it's saying.

Dark days

For other examples:
John Hilliard p.32
Rut Blees Luxemburg p.66
Todd Hido p.69

In the introduction to his photo book, *The Last Cosmology*, Kikuji Kawada writes, 'I was born at the beginning of the Showa Era. There was a great war during my boyhood and I lived through the period of re-construction and growth. Now I approach the evening of life. The final annular solar eclipse and the last total solar eclipse of the 20th century, and such phenomenon as the transit of Venus, were symbols of the end of the Showa Era'.

While mostly photographed in Japan, Kawada's images of cosmological events and abnormal weather are more concerned with a time than a place. Dark and underexposed, his photographs are full of mystery. The dense blacks and weighty skies carry with them a foreboding quality, representing his memories of a turbulent century and concerns for an uncertain future.

The psychological effect of underexposing results in a sense of questioning unease.

When you underexpose a photograph, everything starts to recede into darkness. Details are harder to make out and shadows become voids of black. As Kawada illustrates, this effect can be used as a metaphor for uncertainty.

To underexpose simply use Exposure Compensation and scroll towards the **–**.

The Setting Sun Toward Pyramid, Tokyo
from the series 'The Last Cosmology'
Kikuji Kawada
1989

Shutter speed and movement

Shutter speed is the length of time that light enters your camera. Slower shutter speeds blur movement because the shutter stays open for longer, whereas faster shutter speeds freeze movement because the shutter opens and closes very quickly.

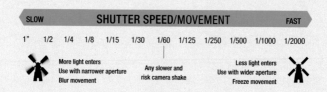

| | SLOW | SHUTTER SPEED/MOVEMENT | FAST |

| 1" | 1/2 | 1/4 | 1/8 | 1/15 | 1/30 | 1/60 | 1/125 | 1/250 | 1/500 | 1/1000 | 1/2000 |

More light enters
Use with narrower aperture
Blur movement

Any slower and
risk camera shake

Less light enters
Use with wider aperture
Freeze movement

When photographing places, shutter speed is usually secondary to aperture, unless, that is, you're photographing a place that moves – water, windswept grass and traffic at night, for instance. In such cases, it's good to use Shutter Priority (**S** or **TV**), the semi-manual mode that puts you in control of shutter speed while your camera figures out the aperture.

Remember, the impact of blur in a photograph is greatest when it's contrasted with stillness. So make sure your camera is mounted on a tripod when shooting at shutter speeds less than **1/60** or everything will look blurred due to camera shake.

Guide to movement

This chart offers a rough guide to the effects of shutter speed when thinking about movement. Use it as a starting point because the extent of blur also depends on exactly how fast the subject is travelling and how much space it is occupying in the frame.

Subject	Freeze	Blur
Water (fast-flowing)	**1/250** or faster	**2"** or slower
Water (placid)	**1/60** or faster	**5"** or slower
Traffic at night	**1/125** or faster	**5"** or slower
Star trails	**N/A**	**10** mins or slower
Windswept vegetation	**1/125** or faster	**2"** or slower
People walking	**1/60** or faster	**1/8** or slower
People running	**1/250** or faster	**1/30** or slower
Clouds (high winds)	**N/A**	**10"** or slower

Fractions are fractions of a second, and the " indicates whole seconds. (So 2" is a two second exposure.)

Aperture and depth of field

Aperture is just like your eye. When it's dark, your pupil gets wider, allowing in more light. When it's brighter, your pupil gets narrower, allowing in less light. A low 'f-number' equates to a wide aperture (big hole). A high 'f-number' equates to a narrow aperture (small hole).

WIDE	APERTURE/FOCUS					NARROW
ƒ/2.8	ƒ/4	ƒ/5.6	ƒ/8	ƒ/11	ƒ/16	ƒ/22

More light enters
Use with faster shutter speed
Shallow depth of field / less in focus

Less light enters
Use with slower shutter speed
Deeper depth of field / more in focus

Because landscapes, buildings and interiors don't tend to move, aperture is generally more of a consideration than shutter speed because, as we've seen on pp. 40–43, aperture controls depth of field. So when photographing static places, use Aperture Priority (**A** or **Av**), which puts you in control of aperture while your camera worries about the corresponding shutter speed. But aperture isn't the only thing that affects depth of field – your distance from your subject and the focal length of your lens do too.

Depth of field gets deeper when focusing on subjects further away, and shallower when focusing on subjects that are closer. So if you're shooting a big vista everything will look pretty sharp, even with a wide aperture (low f-number). However, if you're focusing on something very close, you may find that your depth of field is quite shallow, even with a narrower aperture (high f-number).

Wide-angle lenses – those with shorter focal lengths – tend to create a deeper depth of field. Whereas telephoto lenses – those with longer focal lengths – tend to create a shallower depth of field.

ISO

ISO controls how sensitive your camera is to light. Higher ISOs make your camera more sensitive. This is good for low-light conditions. Lower ISOs make your camera less sensitive. This is good for bright conditions.

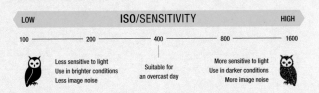

ISO directly affects shutter speed and aperture. Higher ISOs will allow you to use a combination of faster shutter speeds and narrower apertures, while lower ISOs will allow you to use a combination of slower shutter speeds and wider apertures.

Always use the lowest ISO possible for the creative effect you're going for because high ISOs create image noise (fuzziness). This isn't generally a problem for most modern DSLRs until you exceed about **1/1600**.

The standard ISO for an overcast day is **400**. So always ask yourself if it's brighter or darker than an overcast day and adjust your ISO from there. However, if you're working with a tripod, then there's no risk of camera shake. In such cases, always use the lowest ISO your camera offers.

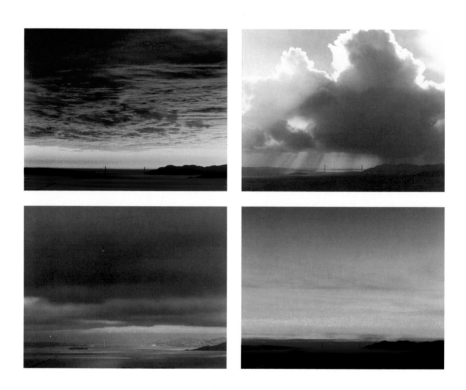

Golden Gate Bridge:
12.14.99, 5:23 pm, 1999;
4.9.00, 7:49 am, 2000;
2.27.00, 5:02 pm, 2000;
2.13.01, 5:59 pm, 2001

Richard Misrach

Good things come to those who wait

Landscapes take millennia to form and cities rise up over centuries. Yet from season to season, from day to day, from minute to minute, light, that all powerful force of nature, means everywhere is constantly changing.

Look here at Richard Misrach's photographs of the Golden Gate Bridge, which he took from his front porch over a three-year period. Even such a familiar view is never fixed. The changing light means that every picture is different. The light takes on an imposing physical presence that rivals the bridge itself.

Sometimes you get lucky, but most of the time you just have to be patient.

This is the 'when' of our 'what, when, how' trio. It's a matter of season, time of day, weather and waiting. Sooner or later the light will offer you what you're looking for; you just have to be prepared and, believe me, the most perfect light often comes and goes in an instant.

So let's spend the day together to see how light can profoundly affect the look and feel of a place. And where better to start than dawn?

Morning glory

The smell of morning dew. The crisp air on my face.
The distant sound of birdsong echoing through the silence.
I dream of England as I gaze at Harry Cory Wright's timeless
photographs of pastoral scenes bathed in the warm light
of dawn.

The golden hour occurs a few moments after sunrise or before sunset.

Landscape photographers are early risers. They are attracted
to the rising sun, with its golden-hour hues and texture-
defining shadows. It's a distinctive light, which radiates a
comforting sense of well-being. And there's more. A misty
morning will imbue your pictures with atmosphere. This
heightens depth, as far-off subjects fade away into the
distance.

Oh, and one final thing. The light is always best just before
the 'official' sunrise. So to make the most of your gift from the
golden hour, arrive half an hour early. This means you'll catch
the whole show and have plenty of time to set up. What better
way to start your day?

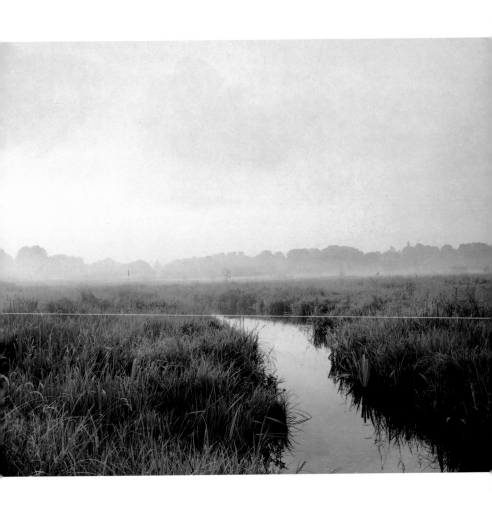

*Journey Through
the British Isles*

Harry Cory Wright
2006

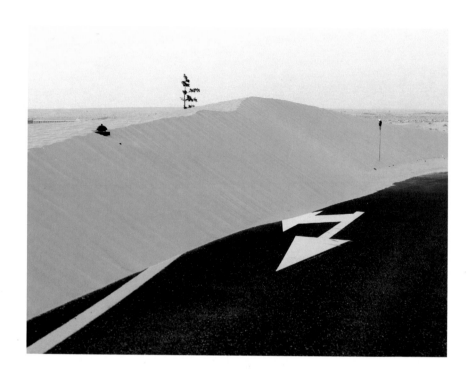

Untitled
from the series 'Desert Spirit –
Dubai, 2007–11'
Philippe Chancel

Softly, softly

It's as if that split arrow is the road's only defence against the advancing desert. Inch by inch, year by year, the sands of time are determined to reclaim the landscape and erase man's efforts to tarmac the terrain.

In this photograph Philippe Chancel makes use of flat light to cast an air of subdued indifference over the situation. Without the dramatic contrast caused by bright highlights and dark shadows everything seems slower and more contemplative. Here, the light suggests the passive inevitability of time.

The flat light of an overcast day makes images feel 'quieter'.

Blanket cloud acts like a giant sheet of diffuser as the intensity of the sun is spread out across the whole sky. This evenness reduces contrast and makes exposure metering more straightforward, as you're not contending with extremes of light and dark.

That said, an overcast sky is still surprisingly bright. So if you want the sky to occupy more than half the frame, you may need to use Exposure Compensation (scroll towards the +) to avoid underexposing the landscape. This is especially true if the landscape is made up of dark features, like vegetation.

For other examples:
Mitch Epstein p.16
Bernd and Hilla Becher p.111

Hardliners

For other examples:
Floto + Warner p.39
Kathy Ryan p.108
Charles Duke p.118

Robert Adams shows us another desert. This one an arid plateau in the American West dotted with prefab houses. All boxy, pitch-roofed and pristine, this ready-made community looks innocent enough, but there's something about that foreground shadow. Creeping out from the house, it could be the outline of a church, leaving its mark on the ground like an ominous symbol of Manifest Destiny.

Hard light accentuates angles, draws out surface texture and results in extreme visual clarity.

Because unobstructed sunlight is so intense, subjects are put under more scrutiny – nothing can hide from its glare. The excess of light will also offer you up faster shutter speeds and narrower apertures, which causes everything in your image to be sharper, giving absolute visual clarity.

This also means that strong, decisive shadows become ever-present in your image. See how Adams has adjusted his composition to account for the shadow. He treats it like an object, no different to the house. This creates balance, but also suggests that the shadow is the subject.

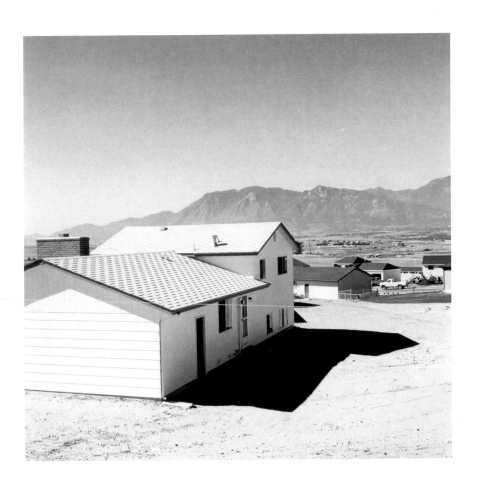

Newly Completed Tract House,
Colorado Springs, Colorado
Robert Adams
1968

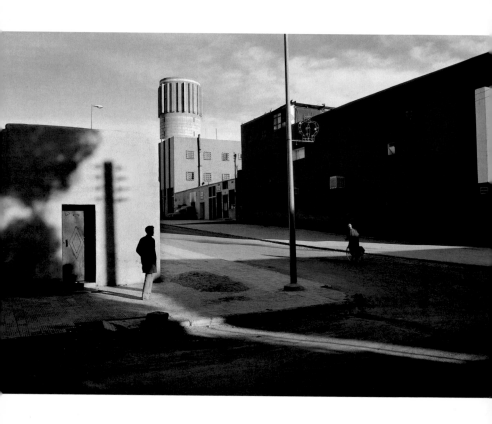

Ouarzazate, Morocco
Harry Gruyaert
1986

Shadowy stories

What moment has Harry Gruyaert captured here? In terms of action, we're left to ponder the presence of a lone man and passing cyclist. Nothing remarkable about that. But when these figures are pictured navigating their way in and out of those long shadows, the street corner becomes pregnant with possibilities. What does it all add up to? I'm not entirely sure. I just know I love it.

Late afternoon light is beautiful but fleeting.

When the sun is low in the sky, shadows grow like vines and surfaces once illuminated ebb into darkness. The strong directional light also means facades are either light or dark, making architecture look all the more angular. It's a magical time, but shadows like these are always on the move until, soon enough, they evaporate completely.

While Gruyaert's image may seem timeless, the paralysis is deceptive. As all the elements were falling into place, his wits would have been acutely heightened by the knowledge that everything around him was shifting. So when shooting in such light, anticipate the moment and be ready and waiting.

For other examples:
Simon Norfolk p.35
Rinko Kawauchi p.44
Richard Misrach p.52

Sundowners

For other examples:
Steffi Klenz p.107
Joel Sternfeld p.113

When Alec Soth visited Niagara Falls he was less interested in the spectacle itself and more so in the cheap motels where newly-wed couples spend their honeymoons.

Here Soth photographs such a motel at twilight. Everything is still. The pool is glassy, the seats abandoned and the room doors closed. As day turns to night, the scene starts to feel a touch melancholic. One senses that tomorrow the flow of couples will continue, with those checking out being replaced by others checking in.

Twilight is evocative. It possesses a quality that is both calm and ominous.

When the sun sinks below the horizon, the world falls into shadow. This plays with our perception of depth. For a few ambiguous minutes everything seems flat. It's as if the world is taking a breath in preparation for the long night ahead.

This is also when street lights flicker into life and the mix of artificial and natural light creates a very distinctive atmosphere. Soth contrasts the cool foreground blues with the warmth of the motel lights and the setting sun beyond. If photographed at any other time of day, the picture would be saying something very different.

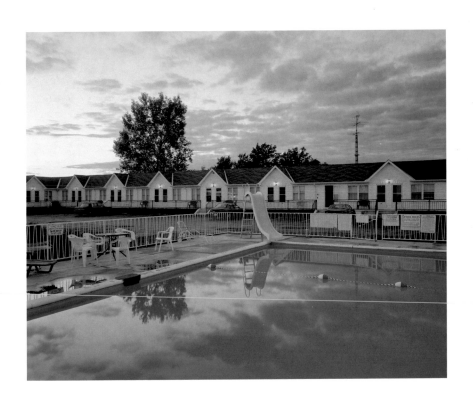

A-1 Motel, Canada
Alec Soth
2005

Shady characters

For other examples:
Todd Hido p.69

Brassaï was his name and he stalked the streets of Paris at night, a time when the city was infested with prostitutes, curb crawlers and blood-hungry gangs.

Here Brassaï photographs 'Big Albert's Gang'. Starkly illuminated by what looks to be car headlights, one wonders what dodgy deal is taking place around the corner. The dramatic lighting may make these men appear like actors, but don't be fooled, because they are thugs. Thugs who eventually stole Brassaï's wallet, even though he paid them handsomely for their picture.

At night the city is transformed into a stage.

In cities after dark, street lamps, illuminated doorways and car headlights act like stage lighting. Generally, the quality of light is hard and directional, which creates bright highlights and dark shadows. Add some evening mist and rain-soaked streets and you've got yourself a million-dollar film set.

If you're interested in architecture, use a tripod and a low ISO. If you're on the lookout for people, travel light and increase your ISO so you can hand-hold your camera. Flash? Forget it. Let the ambient light do all the work.

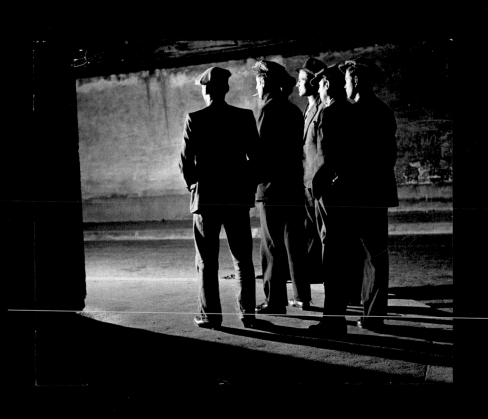

Big Albert's Gang
Brassaï
1931 or 1932

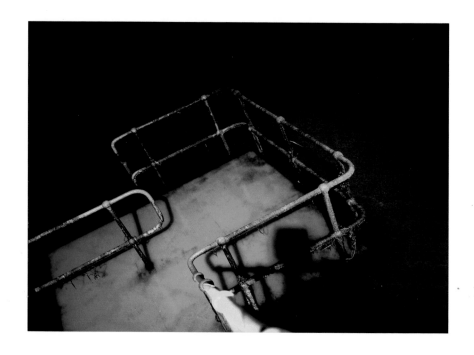

Ffolly
Rut Blees Luxemburg
2003

Colours of the night

We could be looking at a rusting section of the *Titanic*, as it lies alone at the bottom of the ocean, illuminated in the darkness by the probing light of a submersible camera.

This is, in fact, a platform jutting out into a river, but the quality of light in Rut Blees Luxemburg's photograph sets our imaginations on a less literal course. For her, the artificial sources that radiate through the evening hours reveal a city's secret stories. Stories suppressed by daylight and coaxed out by the night.

Places that appear nondescript during the day come alive at night.

For a few hours each night, a sodium glow seeps through the city. Any natural light from the moon or stars is contaminated by shades of orange, yellow and green. Seen in these acidic hues, the urban corners that Luxemburg photographs, such as stairways and car parks, become dislocated from reality. Ominous yet innocuous, they feel like fragments recalled from a dream state.

Shooting in colour under artificial light can be hard to predict and often the results are surprising. You can read all the theory about colour temperature, but the best way to attune yourself to the effects of different light sources is to simply start shooting.

For other examples:
Todd Hido p.69

Bedtime stories

For other examples:
Julius Shulman p.11
Rut Blees Luxemburg p.66

Todd Hido is a kind of ghost who haunts suburbs at night. No one sees him. No one hears him. He just drives around and photographs the ambiguous stories that emanate from anonymous homes in the darkness.

This house, photographed from across the street, recedes into the inky black. It's all but lifeless apart from that golden glow in the top window. Who is in that room? Are they alone and what are they doing?

At night, details become lost in the dark and your imagination takes control.

It happens every day and we take it for granted, but when night falls, everything changes. And I'm not just talking about the light. Roads are deserted, cities are silenced, time seems to slow and, if you find yourself wandering alone, even down familiar streets, you take on the role of an outsider.

For Hido, 'night' is a time and a place that allows him to step outside the literal world and into one ruled by his imagination. Tap into this psychological state and your photographs become full of unanswered questions. For a photographer, that's the richest territory of all.

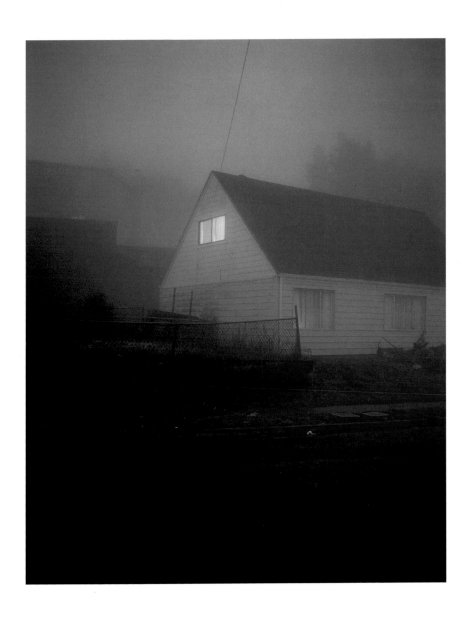

#1975-a
from the series 'House Hunting'
Todd Hido
1996

Controlling colour

Light comes in all sorts of different colours, or temperatures.
Household tungsten lights are orange, or warm. Natural light
is blue, or cool, and becomes much warmer as the sun rises or sets.

Generally, we want our photographs to look 'neutral',
meaning they have little or no colour cast. This is what
your camera's White Balance (**WB**) presets are for. Just
match the **WB** setting to the conditions, et voilà.

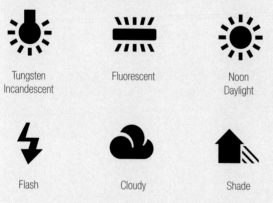

Tungsten
Incandescent

Fluorescent

Noon
Daylight

Flash

Cloudy

Shade

But as we've just seen, when photographing places, you
can use colour to provoke different emotional responses.
Warmer hues can feel more nostalgic, cooler hues can
be quite unsettling, and the varying colours of artificial
light can instil all sorts of ambiguity in your image.
So don't always strive for neutrality by using White
Balance presets and instead embrace the unexpected.

Shooting RAW

Your digital camera saves images in two ways: JPG or RAW.
RAW files carry more information because they are 'uncompressed',
while JPGs sacrifice information to create a smaller file.

Shooting RAW gives you more flexibility and control
when adjusting colours with image-processing software.
Try to adjust a JPG file in the same way and your image
will turn nasty. So, my advice would be to shoot RAW,
especially in extreme conditions, while using Auto White
Balance (**AWB**). Then tweak the colours afterwards.

Black and white

With black and white, colour temperature is irrelevant.
Instead the quality of the light becomes all important.
Soft light reduces contrast, while hard light increases
contrast. RAW files are always in colour. So, even if you
intend for your image to be in black and white, shoot
RAW and then convert that file using image-processing
software rather than using your camera's black and
white mode.

Essential filters

Filters should be handled with extreme caution because, if used flagrantly, you'll end up with some seriously naff pictures. My advice is to stay well clear of any colour filters. Camera club people love these, especially the orange ones, as they make everything look like a sunset. Any special-effect filters are best avoided, too. This is not the eighties.

Not all filters are evil, however. In fact, some are essential when shooting landscapes and architecture. Here's a rundown of the filters to make friends with, which work across colour and black and white.

Skylight or UV filter

These are great. Mainly because they don't really do much at all. A skylight or UV filter is a clear piece of round glass that you screw on to your lens to protect it from dirt and scratches. Compared to your lens these filters are cheap, so always have one in place. UV filters also reduce haze, but the effects are very subtle.

Polarizing filter

A polarizing filter reduces reflections when shooting water and glass. This is a round filter that you screw on to your lens. It's made up of two rings and, once in place, you can rotate the outer ring to vary the extent of the reflections. Usually the results are quite subtle, so look carefully through your viewfinder while rotating to see how it's cutting out the reflections. Polarizing filters also darken blues, creating a greater contrast between sky and clouds.

Neutral-density (ND) filter

This is a grey filter, usually square, that reduces the amount of light coming through your lens without creating a colour cast. This is handy for when you want to use longer shutter speeds (in order to blur movement) or wider apertures (to create a shallow depth of field) in bright conditions, because without one, everything would be overexposed. The darker the filter, the more extreme the effects.

Graduated ND filter

This does the same thing as a normal ND filter, but rather than provide a solid tone, it fades from grey through to transparent. Position the darker half over the sky and you'll draw out more of the detail that would usually be burnt out. Both kinds of ND filters come in a range of densities, from very light to very dark.

Size matters

When buying a circular filter, you need to make sure it's the right size for your lens. Most lenses have their diameter written on them. Look for this symbol: **Ø**. If it's not there then you'll need to measure the diameter of the lens across its widest part. We're dealing in mm so you may be slightly off. The good news is that lens diameters come in standard sizes, so just revert to the nearest standard size which is likely to be one of these: **49, 52, 55, 58, 60, 62, 67, 72, 77.**

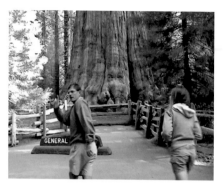
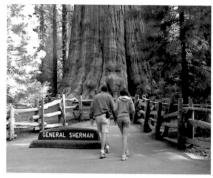
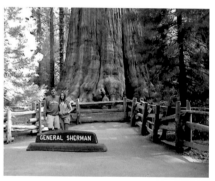
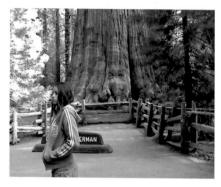
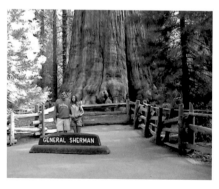
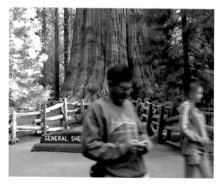

Stills from my film, *General Sherman, The Largest Living Thing on the Planet* (2004), showing a man posing with his daughter while I was off-frame taking their picture.

Let me tell you a story

I was filming the largest living thing on the planet – a giant Californian sequoia tree called General Sherman. While filming, a man asked if I would take a picture of him and his daughter in front of the tree. He handed me his camera, I took the shot and gave it back.

He squinted at the picture, dissatisfied. There was someone in the forest behind them, the presence of whom seemed to bug him. He insisted I take another, this time making sure no one else was in the composition, which was actually quite tricky at such a crowded spot. Eventually I managed to get the shot and the man walked off happy.

Every photograph is a manipulation of the truth.

It was an innocent manipulation, but, even so, the man wanted to represent this place in a very specific way. One that wasn't entirely truthful. Like so many of us do when visiting natural wonders, he wanted to edit out the coachload of others to make it appear as if he was alone in the wild.

To a greater or lesser extent, we all manipulate the truth when taking pictures. It can be as subtle as waiting for the 'right' moment, or being very selective with framing. But, as we're going to see, sometimes photographers adopt techniques of manipulation that are far more overt than they are covert. And in so doing they actually manage to reveal something more truthful about the places they photograph.

MANIPULATION

Colour
manipulation

For other examples:
Rut Blees Luxemburg p.66
Thomas Ruff p.85

On the one hand Richard Mosse's landscapes are very traditional. Compositionally they are classics, in line with any of the old masters. But then there is the colour. This transforms the landscape into something otherworldly. Yet, strangest of all, his scenes still feel so real.

For his series 'Infra', Mosse photographed the war-ravaged landscapes of the Congo using a military reconnaissance film that registers live vegetation in lurid pinks and reds. By shifting the use of this film from a functional tool of war to fine art, Mosse challenges our perception of landscape and the traditions of war photography.

When it comes to colour, what is the truth?

The colour hits you instantly when you look at Mosse's images. But manipulating colour in photography doesn't always have to be so in-your-face. Glance outside the window on a sunny day and then again on a cloudy day and you'll see that nothing has a true colour. It's much more about how you choose to represent it and why.

Saturated images pack a punch. They arrest attention and seduce us with their vividness. Subjects become hyper-real, especially if the colours are pushed to the point of artificiality. The muted hues of a desaturated image, on the other hand, feel calmer and more contemplative.

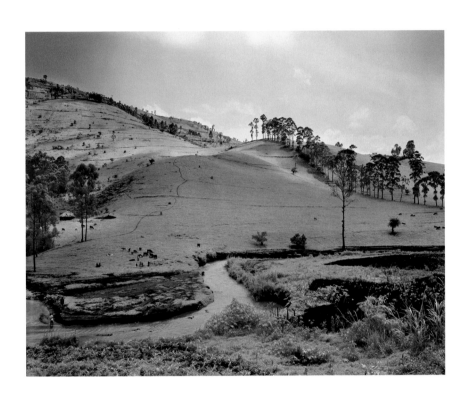

Men of Good Fortune
Richard Mosse
2011

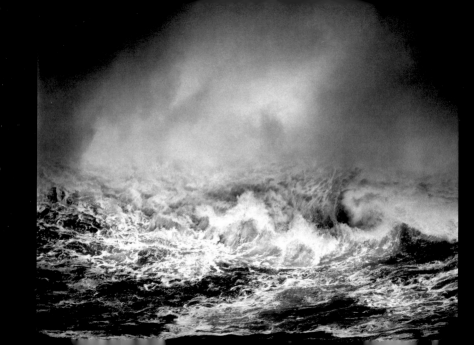

Tonal manipulation

In DoDo Jin Ming's seascape it's hard to decipher where the water meets the sky. Borrowing from photographic techniques used by the likes of Gustave Le Gray in the nineteenth century, Ming makes two exposures on a single negative – one of sky and one of water – to represent nature at its most awesome.

That alone is a grand manipulation. But what I want us to look at here is Ming's use of black and white. By abandoning the literalness of colour, Ming edges towards something less defined. When reduced to tones, this angry water can be perceived as its opposite: that of a raging fire. If I were to throw myself into the brink, would I drown or would I burn?

Black and white reveals an unseen world of texture and tone.

Shooting in black and white means colours are translated into tones. This draws out a subject's textural qualities. Rather than contend with saturation, contrast levels become your main concern. Do you opt for high contrast to create dramatic areas of black and white, or low contrast so you're dealing with softer shades of grey?

For other examples:
Kikuji Kawada p.47
Mitch Dobrowner p.19

Light your own way

For her series 'Unseen Forest', the British photographer Tina Hillier spent one night alone in South African woodland. Every so often, prompted by fear or curiosity, she would take a picture and, in so doing, illuminate the black with the light of a flash.

The flash helped Hillier navigate her way through the forest, although at the same time its immediacy was disorientating. Its hard, directional quality isolated details, but her photographs do not form a map of the forest. Instead it remains mysterious, enticing and threatening, much like Hillier's relationship with the unfamiliar country she was visiting.

Artificial light allows you to take control of what a place looks like.

When we photograph a place we often work with natural light, particularly if it's outside. But when you bring your own light to a location you transform it into something else. Whether it's a simple flash gun or large, elaborate set-up, artificial light means you can make the location look and feel exactly the way you want.

Hillier's use of artificial light creates tension between the seen and unseen. Somewhere along that boundary of light and dark our imaginations take control.

Untitled
from the series 'Unseen Forest'
Tina Hillier
2014

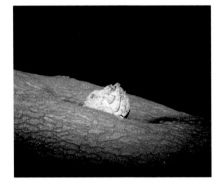
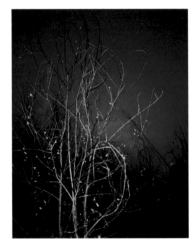
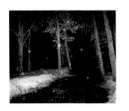

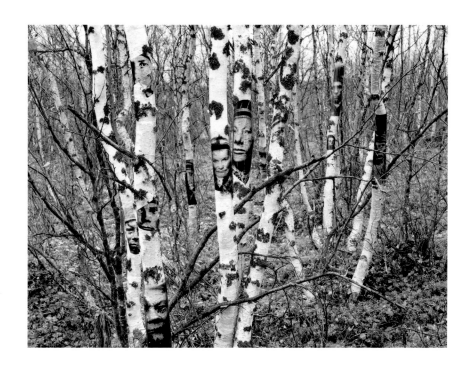

Imaginary Homecoming 5
Jorma Puranen
1991

One plus one equals three

Here's another photographer working in the woods. On discovering a collection of historical portraits of the Sami people, Jorma Puranen made copies and then placed the images in the forests and fells of northern Scandinavia. In so doing, this 'Imaginary Homecoming' metaphorically allows the Sami to reclaim their ancestral landscape.

In this instance, Puranen has pasted their portraits on birch trees. Camouflaged at first, soon faces emerge from the spotted barks like ghosts haunting the woods. As more and more faces appear, past and present overlap and the landscape becomes layered with history. All of a sudden, whispers from a bygone era echo through the trees.

For other examples:
Lee Friedlander p.27
William Henry Jackson p.86
Charles Duke p.118

Placing objects in an environment unlocks hidden layers and meanings.

Using props is a case of 1 + 1 = 3. Let me break it down. In this photograph you have Scandinavian birch trees, which, on their own, really only tell us what some trees in Scandinavia look like. Then you have the Sami portraits, which, on their own, really only show us what some Sami people looked like.

When seen individually, these two elements carry their own meaning. But the magic happens when they're put together. By placing these portraits in the landscape, Puranen creates something adding up to more than the sum of its parts.

Pictures about pictures

For other examples:
Joel Sternfeld p.113
Joan Fontcuberta p.114
Charles Duke p.118

Thomas Ruff made his series 'Nacht' during the first Gulf War, a time when TV news was saturated with strange military images of violent operations being carried out in unfamiliar lands.

Tapping into the cultural associations of this new genre of image, Ruff photographed residential Düsseldorf with a night-vision camera. When seen through the green fuzziness so associated with conflict, this benign, leafy street becomes overlaid with all sorts of socio-political connotations. It causes us to reassess our relationship to the familiar. It brings the war unnervingly close to our own front doors.

Creating meaning is as much about technique as it is subject matter.

Think of all the different kinds of images we see in the news, from early camera-phone snaps taken by the public, to CCTV footage, to satellite photographs. These images have a very distinctive look and, unlike those taken with a DSLR, often the quality is poor. They are functional rather than polished and this is why they carry a greater sense of truth or authenticity.

By drawing on the visual traits of specific kinds of imagery, you manipulate the viewer down a road of complex cultural references, which affects their understanding of your subject.

Nacht 12
Thomas Ruff
1992

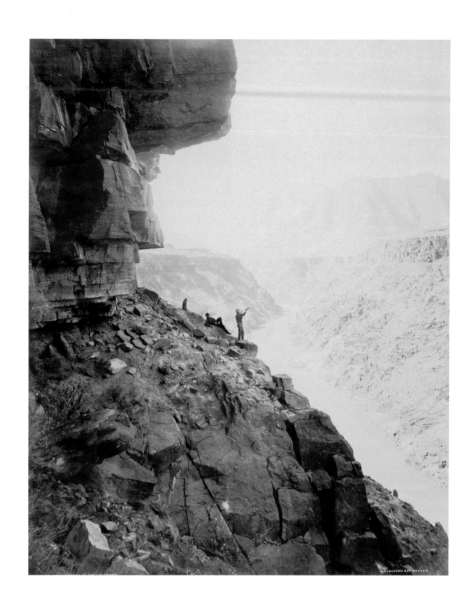

Grand Canyon of the Colorado River
William Henry Jackson
1883

The human touch

In the late nineteenth century, much of the American West was still an uncharted wilderness. Feared by folks back east, the West was perceived as a place of arid deserts, perilous canyons and savage natives out for your scalp.

William Henry Jackson was employed by the government to accompany geological surveys. His brief was simple: make photographs to entice people to move West. In this picture, one man reclines leisurely, taking in the view like a tourist, while the other stands alert, like a scout, surveying the landscape through a telescope. Together, these two figures represent freedom and opportunity.

Including people in your composition radically alters the viewer's relationship to a place.

Jackson would often use people in his photographs to communicate scale, but that wasn't all. Their presence also manipulated his audience's perception of the landscape. People are political, so it's important to think about what they are doing, who they are and how much space they are occupying in the frame.

These two men are tiny in Jackson's composition, but they are placed dead centre. Like the indelible legacy of exploitation they left on the American West, these harbingers of change are impossible to ignore.

For other examples:
Harry Gruyaert p.60
Brassaï p.65
Martin Parr p.99

Invisible truths

Matt Siber photographs elevated roadside signs, then, using Photoshop, he removes their supporting poles so the signs become gravity-defying. Dislocated from the ground and looming large over the landscape, the signs feel like messages from a higher being, yet their declarations of 'SANDWICHES', 'IKEA', 'BP' and 'JESUS' offer us the mundane, not the mystical.

There are two approaches to digital manipulation: 'invisible' and 'visible'.

With 'invisible' manipulation, the viewer is not really aware that the image has been doctored. It still looks natural even though it's no longer a truthful representation of a place. This kind of digital manipulation generally occurs in advertising, editorial and commercial imagery.

However, like many artists, Siber takes a 'visible' approach to his digital manipulation. Here, rather than try to deceive us, he's using Photoshop as an artistic tool to comment on how consumer culture and political and religious messages have left their imprint on the landscape.

There's nothing wrong with digital manipulation. Even in the darkroom, photographers were busy altering their images. Just be aware of your motivations and where you draw the line between truth and lies.

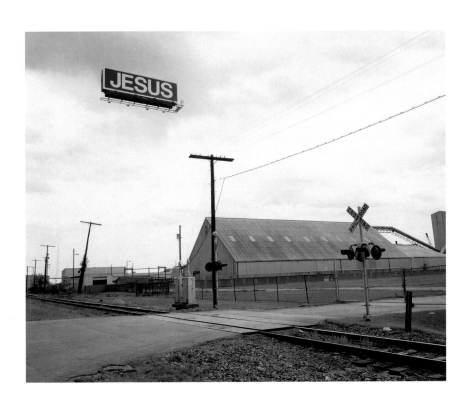

Jesus
Matt Siber
2004

Retouching

Of the many retouching programs available, Photoshop is the industry standard and by far the most powerful. For photographers, though, the key functions of Photoshop can also be found in the more user-friendly program Lightroom.

Photoshop vs Lightroom

Photoshop is aimed at designers, illustrators and photographers. As such, if you're 'just' a photographer you won't make use of most of the features. Lightroom, however, is designed solely for photographers, meaning it only features the tools you need.

If you're going to do hard-core manipulation, such as combining different images or removing large elements from a scene, use Photoshop over Lightroom. It's just more advanced in those areas.

Both programs are ideal for working on single images, but Lightroom is much better suited to 'batch edits', meaning you can import lots of images at the same time and make the same adjustments to them all.

Lightroom also only allows you to make non-destructive edits. That's good. Whereas with Photoshop you can risk permanently altering your original file. That's bad and here's why...

Non-destructive editing

This is the golden rule of image editing. It means that you don't make any changes that can't be undone. Photoshop has 'Layers', which you essentially stack on top of your image and delete if necessary (Window > Layers). Lightroom, on the other hand, 'imports' images rather than simply opening them. This means your original is always left untouched and any changes can be undone before exporting the corrected image as a different file.

What you definitely don't want to do in any program is to simply open your image, make changes, save and close. Once you've done that there's no going back!

Essential functions in Lightroom

These are the tools to get comfortable with when making initial image enhancements. Just remember, you always want your image to look natural, not naff. So small adjustments make a big difference. Other programs, such as Photoshop, Aperture and Capture One, also have these functions.

Basic

When you import an image, the first adjustment window you'll see is called 'Basic'. By moving the sliders you can quickly make changes to the essentials, like colour balance, brightness, contrast and saturation. In some cases, that's all you'll need to do. However, most of the time you'll want slightly more control.

HSL
(Hue, saturation, luminance)

This window gives you very exacting control over hue, saturation and luminance. By moving the sliders you can make these changes to individual colour channels. Hue affects the tint of each colour; saturation affects the intensity, and luminance the brightness. If you're working with a black-and-white image, the colour channels act like 'filters', which affect tonality.

Tone Curve

Next up you'll see the 'Tone Curve'. This allows you to make more precise adjustments to the contrast levels. By moving the sliders you can adjust the highlights, midtones and shadows. The left of the curve represents the shadows, and the right the highlights. As you make adjustments, take note of how the curve changes and you'll soon make sense of it. (Using 'Levels' is a simpler alternative to Tone Curve.)

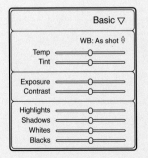

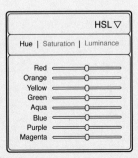

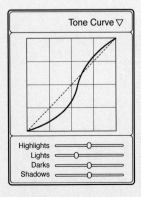

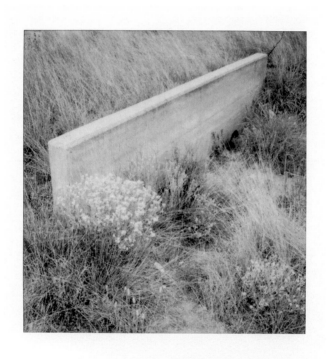

Untitled
from the series 'Scorpio'
Mike Slack
2004

Find your place

Now we're at the biggy – the 'what' of the 'what, when and how' trio. Figuring out what places to photograph could be the result of a personal connection that stirs your creativity. Or it could be sparked by an idea you want to visualize.

This concrete block on a scruffy patch of ground did it for Mike Slack. He told me, 'I made the picture in Marfa, Texas, in the field near Donald Judd's *15 Untitled Works in Concrete*. It's easily overlooked, probably part of a defunct drainage system, but its proximity to Judd's monoliths made it seem like a minimalist artwork.'

Be brave and don't constantly go for the crowd-pleasers.

Your aim might be to take nice photos of famous landmarks. Nothing wrong with that, I suppose. It's just that these locations are very familiar and unsurprising. Almost always, the results tend to be a little generic and feel like a stand-in for the real thing. And that's definitely not what defines great photography.

With its abstract oddness, Slack's humorous homage to Judd makes us regard a little corner of the world differently. Whether your pictures are personal or profound, this is exactly what we should all aspire to when photographing a place. In this final chapter, we're going to look at photographers who achieve exactly that.

Photo therapy

For other examples:
Tina Hillier p.81
William Henry Jackson p.86
Charles Duke p.118

If there's one kind of place that no one can resist photographing, it's sublime scenes of wilderness. I guarantee that even the most hardened of street photographers have a secret stash of home-grown landscape porn hidden away somewhere.

For many of us, the sheer scale of the landscape is unlike anything we usually experience. And then there's the fact that wilderness areas present a kind of antidote to our busy lives. But there's more to it than that. Photography allows us to comprehend our encounters with the sublime. It satisfies our irresistible urge to contain or make sense of something greater than ourselves.

Photographing sublime scenes should be an exercise in mindfulness.

To take great photographs of nature you have to value the experience of being alone in the wild. All too often we experience the sublime in the company of hundreds of strangers. Rushed, distracted and jostling for position, no wonder we come away with superficial snapshots that do nothing to capture the spirituality of a place.

Ansel Adams would spend days in the wilderness, communing with nature. He wouldn't make many exposures and when he did, he captured his deep connection to the natural world. In many respects, to get the shot, you need to get away from it all.

El Capitan, Merced River, Clouds,
Yosemite National Park, California
Ansel Adams
1948

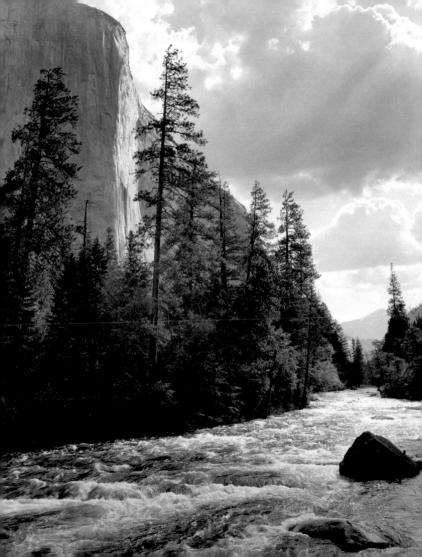

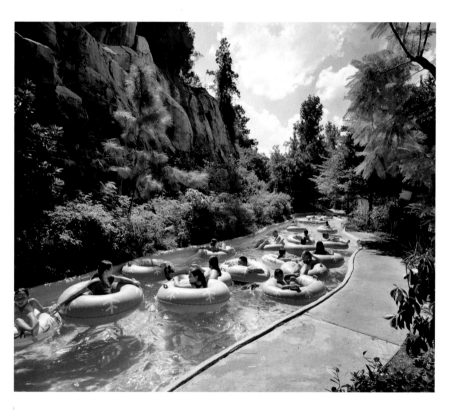

Wild River, Florida
from the series 'Fake Holidays'
Reiner Riedler
2005

Faking it

Bobbing down the chlorinated 'rapids', with fibreglass rocks on one side and a concrete pathway on the other, the only thing wild about this river are the kids.

For his series 'Fake Holidays', Reiner Riedler photographed theme parks around the world that attempt to imitate sublime nature and other iconic landmarks. For many, this is the great outdoors, only better. You won't encounter any dangerous wildlife here and if the water gets too choppy, the control room will simply switch it off.

Artificial places actually confront us with cold, hard reality.

Contrived they might be, but these kinds of places appear to be fulfilling a modern human need. They show us that what we actually yearn for is artifice rather than authenticity. They show us that we draw more comfort from environments made by man rather than nature. Poor Ansel would be turning in his grave.

These manufactured environments offer us everything we want, but nothing of what we need. Now brace yourself, because over the page we're going to see what happens when we do actually encounter the real…

Say cheesy

For other examples:
Massimo Vitali p.20
Henry Carroll p.74

We all know what they're doing. Some of us have probably done it ourselves. They're in search of that 'hilarious' visual trick that's only achievable through the act of photography. By purposefully misaligning their attempts, Martin Parr makes this display of tourist tai chi seem all the more ridiculous, highlighting the superficial way in which we experience our bucket-list places.

It's the tourists themselves who make landmarks worth visiting.

Rather than making a landmark the subject of your picture, use it as a backdrop and focus your attention on everything else that's going on. That's where you'll find your pictures. And behind the humour you'll unearth deeper questions. Why do we travel? What do we expect to find? When did we lose our connection to history and nature?

You probably laughed when you first saw Parr's photograph. Maybe now you actually think it's kind of depressing.

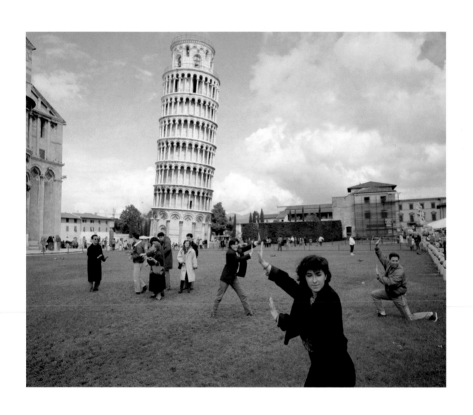

The Leaning Tower of Pisa
Martin Parr
1990

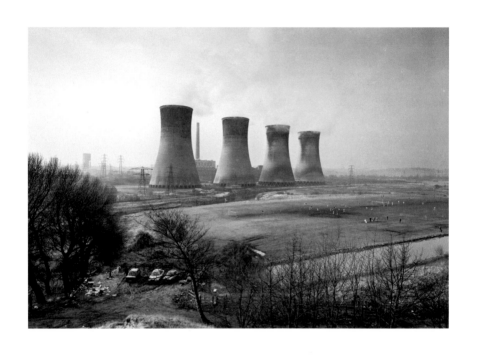

Agecroft Power Station, Salford
John Davies
1983

Negative beauty

This is a landscape exhausted. The trees are bare, horses graze among cars and detritus, the football pitch is being churned to mud and the four chimneys spew out fumes into a choked sky. John Davies shows us England, but it's a far cry from the green and pleasant lands of a halcyon era.

That's not to say Davies's photograph is without beauty. It's an elegant composition that makes use of every corner of the frame. And there's something sculptural about those chimneys. They have a monumental presence rivalling the likes of Stonehenge.

Davies's photograph is a perfect combination of 'what, when, how'.

What: Davies is drawn to a landscape broken by industry. *When*: he photographs the scene during overcast conditions in the bleak midwinter. *How*: he uses black and white and classic compositional techniques. All of this adds up to a very precise representation of the English landscape.

Don't just shoot what you see when you see it. Wait for the right season and conditions. Every aspect of your photograph needs to add up to the whole.

For other examples:
Mitch Epstein p.16
Robert Adams p.59
Bernd and Hilla Becher p.111
Joel Sternfeld p.113

Fresh green pastures

For other examples:
John Hilliard p.32
Harry Cory Wright p.55

The cows graze on a sweeping valley floor washed in beautiful winter sunlight. Behind them a dry stone wall and then a rugged hill, which is gently marked by the zigzag of a path. In contrast to the previous example, Fay Godwin presents England as a pastoral place. A place where man and nature are engaged in a more respectful, harmonious relationship.

Everyone's eyes have an agenda.

Godwin sees the British Isles in a very different way to John Davies. Godwin's Britain is one where ancient and modern sit side by side and agriculture has a relatively benign impact on the land, whereas Davies takes a less romantic view. His is a country where the rural idyll has been sacrificed for the sake of industry.

Neither photographer is taking a more 'truthful' stance. They are just choosing to frame different corners of the same country to show us what it means to them, through their own eyes. No one perceives the same place in the same way. When you look at your own country, how are your eyes filtering what you see?

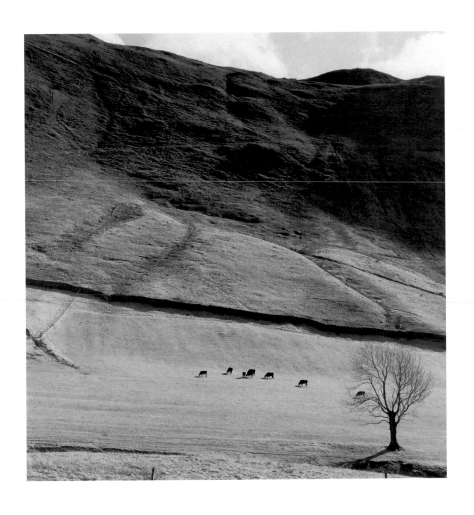

Boardale, South of Ullswater, Cumbria
Fay Godwin
1982

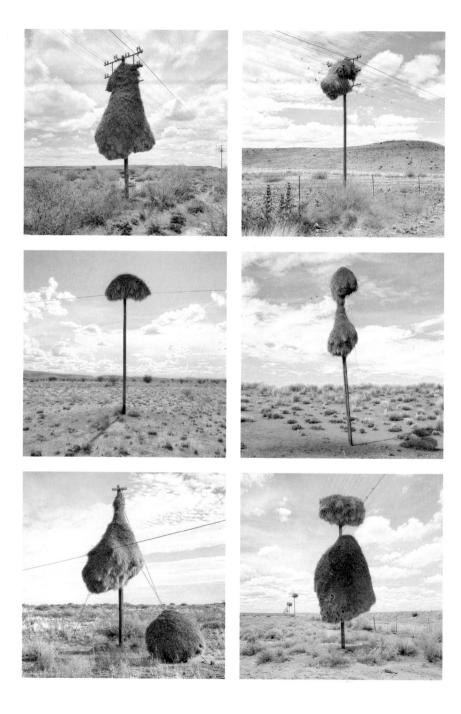

Nature vs man

Dillon Marsh calls his series 'Assimilation' and it's a title
that cuts both ways. There is man, who has cast a web of wires
across the Kalahari. And there are the weaver birds, which use
the materials of the desert to reclaim what's rightfully theirs.

The repetitive poles, which line the landscape to the horizon
and beyond, have now been repurposed and used to build
nests that look otherworldly and alien. All different in size
and shape, some are so burgeoning they are almost humorous.

If left untended, any man-made structure will be reclaimed by nature.

These transformations mean that structures originally
intended for one purpose lead unexpected second lives.
Places such as abandoned buildings, railroads or theme
parks, which once suppressed nature, become havens for life.

Apart from being fascinatingly bizarre formations, these birds'
nests tell us about an ongoing cycle. One in which nature
appears to have as little respect for man's creations as man
does for nature's.

For other examples:
Philippe Chancel p.56
Mike Slack p.92

Assimilation
(Sociable Weaver Bird's Nests)
Dillon Marsh
2010

The suburban sublime

For other examples:
Kyler Zeleny p.8
John Gossage p.43
Matt Siber p.89
Mike Slack p.92
Ying Ang p.117

At first it looks like a mountain, rising up from a flat plain. But then the scale is disrupted by the tracks in the foreground and the monumental is reduced to something more modest.

For her series 'A Scape', Steffi Klenz photographed the gravel pits located at the peripheries of London. The workers who tend to these formations are not concerned with aesthetics, yet Klenz shows us that these places – these 'non-places', with their undulating peaks and subtle tonal variations – have been bulldozed into something surprisingly beautiful.

Sometimes the most beautiful subjects are found 'nowhere'.

We're so often pointed in the direction of 'great' photographs – drive to this sublime viewpoint or famous landmark, queue up with the masses, stand in the right spot and hey presto, you've got yourself a nice piccy. But taking great photographs isn't about going where you're told. It's about making your own discoveries.

The most fascinating places to photograph don't have signposts leading to them. They are the places that everyone overlooks or deems unimportant and boring. A great photographer proves them wrong.

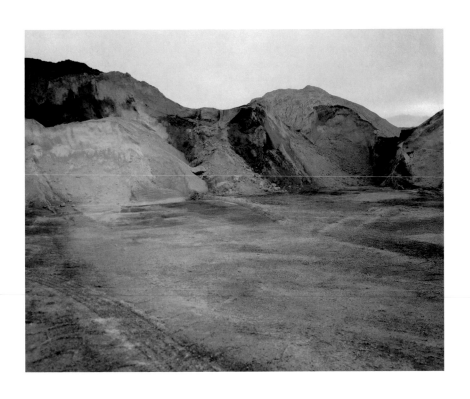

Pudding Mill Lane
from the series 'A Scape'
Steffi Klenz
2005

9:19am, June 19, 2013
from the series 'Office Romance'
Kathy Ryan

Ode to the office

Kathy Ryan found love at work. She didn't fall for a colleague, she became infatuated with the office itself. Working at the *New York Times* building, Ryan noticed that every day, the changing light transformed the office into a more poetic place. Using her camera phone, she started posting her pictures on Instagram and her feed, @kathyryan1, soon attracted thousands of followers.

In Ryan's pictures, daylight streams through the windows and abstracts carpeted corners, piles of papers and office furniture. She takes the idea of photographing a 'non-place' to the extreme and opens our eyes to the unexpected beauty that surrounds us every day. And there's no better tool to do that than your trusty camera phone.

Invest in your eyes, not just your equipment.

Of course, a camera phone's lens and sensor are no match for a DSLR. But even if image quality is your main concern, you can still think of your phone as a sketchbook and use it to record ideas and subjects to return to later.

I love the fact that Ryan only uses her phone. It makes her pictures all the more honest. There's no excessive planning here – she's just responding to her everyday surroundings as and when they offer her something worth saving.

Gridlock

For other examples:
Richard Misrach p.52
Dillon Marsh p.104

When I look at the photographic grids of the husband-and-wife duo Bernd and Hilla Becher, I always wonder about the realities of their relationship. Their pictures of water towers and other industrial structures are so controlled. Clinical, even. On their days out shooting, did Bernd ever throw a wobbly if the light changed? Did Hilla ever get grouchy about her husband's driving? They were humans after all, so why did they prevent an ounce of emotion from creeping into their pictures?

This machine-like cataloguing was their conceptual masterstroke. By presenting their studies in a grid and keeping everything the same, from the composition, to the light, to the subject matter, we're invited to compare what distinguishes one water tower from the next.

Great typologies focus on subjects that are the same but different.

A 'typology' is a classification according to type. It's a little like dividing things into species. These water towers all serve the same purpose, yet no two are the same. This forces our interest in them to shift from function to form.

The Bechers demonstrate that photography, with its perceived neutrality of recording, is perfectly suited to creating typologies. It's all about consistency. Format, composition and lighting need to be the same. Do this and the viewer's attention will be drawn to the discrepancies between the subjects, rather than the way you are photographing them.

Water Towers
Bernd and Hilla Becher
1967–80, printed 1980

Better late than never

For other examples:
Mitch Epstein p.16
Stephen Tourlentes p.24
John Davies p.100

What's Joel Sternfeld up to here? There's something profoundly empty about his photograph. No one is around and the road is deserted, with only a few cars parked under the trees. And the composition. There's just a little too much foreground. It's like we're being asked to contemplate a subject that's been removed.

This is precisely Sternfeld's plan, because the subject has been removed. Not by any computer trickery, but by time. Read the accompanying text and suddenly the photograph becomes laden with significance. This patch of dirt asks us to contemplate the state of a nation. To question whether, two decades later, anything has actually changed when it comes to race relations in the United States.

With photography, subtlety leads to significance.

The understated nature of Sternfeld's image and the factual tone of the accompanying text is what makes this work so powerful. Any trace of personal photographic style is practically invisible, which, I suppose, *is* his style.

To be a distinctive photographer, to make images that really stand out, you don't need to adopt overt techniques and processes. Instead you need to give everything over to your subject matter. If you want a place to be heard, you, the photographer, have to keep quiet and allow it the space to tell its story.

Across the street from 11777 Foothill Boulevard, Lake View Terrace, Los Angeles, California, November 1993
from the series 'On This Site: Landscape in Memoriam'
Joel Sternfeld

Across the street from 11777 Foothill Boulevard, Los Angeles, California, November 1993

Rodney King, a black motorist, was beaten by four white Los Angeles police officers in the early morning hours of March 3, 1991. King was pulled over after leading police on an eight-mile high-speed chase; he was drunk and resisted arrest. Some twenty officers looked on as extreme force was used to restrain him. George Holliday, one of many local residents who witnessed the incident, recorded seven minutes of the beating with his new camcorder.

King's injuries included eleven skull fractures, a shattered eye socket, a broken leg, and nerve damage that left his face partially paralyzed. Sergeant Stacey Koon, one of the four officers accused of using unnecessary force, wrote in his report that King's injuries were of a 'minor nature'.

The four officers were acquitted of all criminal charges by an all-white jury.

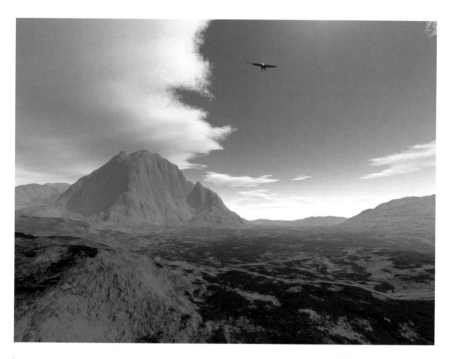

Bodyscape: Tongue
from the series 'Orogenesis'
Joan Fontcuberta
2003

Tongue in cheek

Welcome to the inside of Joan Fontcuberta's mouth.
Or, more precisely, his tongue. Who would have thought this
was a place where eagles glide through big blue skies and
mountains rise up from epic expanses of red earth?

This, of course, is not Fontcuberta's tongue. It's a virtual
representation of it when put through 3D imaging software
designed to interpret maps. Fontcuberta has also processed
historical landscape paintings and the results are equally
odd. These clichéd, manufactured landscapes bear no
relation to the original image. I wonder whose idealized view
of the natural world has been programmed into the software
and what library of cultural references the designers were
working from?

Even a fictitious place has to draw its reference points from reality.

Many photographers create their own landscapes. Some
make physical models and photograph them, like Kim
Keever, James Casebere and Thomas Demand. Others use
computer software, like Fontcuberta. Yet the fascinating
thing about all fictitious places is that they can never be
entirely made up. They still have to draw their reference
points from somewhere real.

If you were to create a place from scratch, what parts of the
world would you borrow from?

There's no place like home

For other examples:
Rinko Kawauchi p.44
Kikuji Kawada p.47

All is not what it seems on Australia's Gold Coast. Hidden under the sheen of this booming, beachside city is a darker underbelly, summed up by its unofficial motto, 'A sunny place for shady people'.

When Ying Ang returned to her childhood stomping ground she photographed the city in an apparent state of inertia. Nothing is happening in this scene. The beach ball just sits there like an inflated emblem of unfulfilment. In other pictures, we're shown the perfectly arranged yet lifeless rooms of million-dollar mansions and suburban scenes sparsely populated with residents not doing anything in particular.

Returning to places from your past can unlock all sorts of ideas and emotions.

In the introduction to this book I mentioned finding those places that stir your emotions. Well, nowhere does that like places from your past. The act of leaving and returning puts you in a unique position. Someone who can be subjective and objective. An insider and an outsider. This allows you to see a place like no one else. It allows you to uncover the truths that everyone else is blind to.

Rio Vista Boulevard
from the series 'Gold Coast'
Ying Ang
2011

Untitled
Charles Duke
1972

It's lonely out in space

LOCATION
Your places

Between collecting rock samples and conducting gravitational experiments, the astronaut Charles Duke found a quiet corner of the moon, pulled a family snapshot from his spacesuit and took a picture of it lying on the lunar dust.

His photograph is not perfect. It feels like it was taken in haste and the focus is slightly off. Yet of all the pictures taken on the moon, which include sublime shots of the earth rising and landscapes pitted with impact craters, this, for me, is the most enlightening. Enlightening because it's a photograph of the moon as seen through the eyes of an individual. It speaks about Duke's sense of separation from everything he knows and loves. It's the result of someone responding to an overwhelming awareness of place.

Showing the world through your eyes. That's what it's all about. Some people might not like what you see or how you see it. It really doesn't matter, as long as you find the places that mean something to you and communicate that connection through your photographs. Hopefully this book, and the others in the *Read This* series, have helped you with that. Just always remember:

However far you travel, no matter how unfamiliar your new environment, there's one thing you can never leave behind – yourself.

Legal matters

As a photographer it's always important to know your rights, so I asked Owen O'Rorke, a specialist in media and intellectual property law, to set us straight on where we stand legally when it comes to photographing places.

What are the general legal considerations for photographing buildings and places?

As a general rule, the more man-made objects in a scene, the more rights are likely to be involved. But the photography of objects displayed in public places (including permanent structures and sculptures) is generally allowed – even in countries that recognize buildings as artworks capable of copyright protection (as the US has since 1990).

Issues may come up when protected works, or litigious people, are caught in a shot by accident: is the picture on the wall incidental to the picture, or is it part of the subject? If a person is identifiable in a scene, do they have rights that might limit your commercial exploitation of the image? Or what if a scene has been carefully curated – do the rights belong to the photographer, or the arranger? The public domain is generally a free canvas, but there may be hidden legal risks.

When should I obtain a signed 'location release'?

With certain exceptions, a location release isn't about the right to take photographs of a place; it's about the physical right to enter a place with your equipment and start working.

Accessing private property without consent, to get closer to a subject or pick a preferred spot, is going to be trespass, although verbal permission from the owner is generally sufficient. Keep in mind that some property owners might expect a fee.

However, if the area where you are shooting is subject to security, it might be desirable to have papers evidencing you are there by right. There also are a limited number of public places where shooting for commercial purposes might need some kind of state, civic or council permit: in certain US national parks, say, or if you want to set up obstructive equipment in a city centre. Photographing certain subjects can attract unwanted attention from relevant authorities or private security: airports, government buildings, even the insides of clubs or restaurants. Whether a place is owned privately or by the state, the owners can (to some degree) set their own rules about what you do there.

What difference does my intended use of the image make?

You can usually make commercial use of your work even without a signed location release. The exceptions include situations where

the shot contains either another person's protected work of art, or information about them (e.g. an identifiable face or location) that constitutes a breach of privacy or confidence. Exceptions may be available for journalistic uses, such as criticism of an artwork or an investigation made in the public interest.

If the intention is to sell an image for marketing or advertising, issues of false endorsement may arise. Consider whether a particular view, place or building has specific associations with some legal entity (a person, a company or a state body) who might argue that your use of the image is implying an association.

If members of the public are part of the scene, do I need to worry about model releases?

The more the individual is both identifiable and the subject of the image, the greater the risk – but the real legal risks come with more overtly commercial uses of the image.

Where members of the public are simply caught in a shot, and are in a public place, obtaining release forms is impractical, and there is unlikely to be any basis for complaint. (Where you see pixelated faces in the background of a shot, e.g. on Google Street View, in CCTV or in the news, there is likely to be a context-specific reason: data protection or libel sensitivity, or editorial codes and guidelines around children.)

Where the use is intended for advertising, if you are not willing to crop or digitally manipulate the image to remove or anonymize the individual, efforts should be made to get an adequate release form covering the type of use intended. Simple caution and courtesy can save unhelpful complaints down the line.

Can someone stop me from photographing their property from a public road?

You're generally within your rights to shoot *from* a public place, but beware of privacy or harassment considerations if your actions impose upon the right of the owner to a private life (in European jurisdictions). Particularly if using a long lens.

If your photograph is intended for use in advertising, however, there will be other considerations: for example, in the UK, the relevant advertising code states that written permission should be obtained before portraying members of the public or their identifiable possessions. Their homes or registration plates would fall into this category.

I have heard that some buildings are registered trade marks...

Unlike copyright and design rights, which protect artistic or industrial works, trade marks protect commercial trading rights. This might mean the right to put a certain 'mark of origin' on a T-shirt or key ring. Some iconic buildings may be subject to trade mark protection by a state or civic authority – for example, a particular graphical representation of a building's outline can be protected. (The New York skyline attracts more trade mark applications than most other locations.) However, this generally does not prevent others from taking and exploiting their own photographs of the same buildings. The test of infringement will be whether, first, the image is confusingly similar to something that has been registered as a trade mark and, second, whether it has been used in relation to particular goods. This will always be context-specific so it may require research.

Are buildings copyright protected?

Although copyright and other intellectual property rights can and do exist in buildings, these chiefly exist to protect the architect from copycat designs of their structure. They do not necessarily prevent the likeness of a public building from being photographed or painted, or if they do, some breed of 'fair use' exception is likely to exist.

In the UK, for example, this is covered under s.62 of the Copyright, Designs and Patents Act of 1988. The same exemption also applies to photographing '*sculptures, models for buildings and works of artistic craftsmanship, if permanently situated in a public place or in premises open to the public*'. So this would apply to a building or statue, but not necessarily to 'pop-up' art in a public venue.

Many (but not all) European countries, and the US, have similar 'public place' exemptions. However, there are differences – for example, US law does not extend to sculptures, and EU law does not require every country to apply the rule in the same way. This means the exemption could vary depending on the subject of the photograph, whether it was on permanent public display, exactly where the photograph was taken from, and what the intended use was. So travelling photographers would benefit from a little local knowledge.

Can anyone own a view? For example, where the viewing platform is privately owned, such as the view from the top of the Empire State Building.

Fortunately not – or at least, not by means of intellectual property. But if you are on private property and, in effect, relying on the permission of the owner to be there, the owner can enforce their own terms of entry (which may include restrictions on photography). So do not assume that simply buying an entrance ticket gives you rights to photograph freely and use the pictures as you wish.

Similar restrictive terms may apply, but for different reasons, in theatres, cinemas or galleries. In addition to the venue's contractual terms, there are clear restrictions on taking photographs of underlying works which, although public, are nonetheless subject to copyright protections. This can include photographing artworks (although older paintings may be out of copyright) just as you cannot film a movie or a play. And shop or restaurant owners have the right to ask you to leave their premises, even if they can't confiscate your equipment.

What sort of subjects are copyright protected?

As noted above, the rights around theatrical and compositional works differ from those around public sculpture and buildings. It remains something of an open legal question into which category a 'still life' arrangement made for a photograph would fall, and hence whether the rights to exploit the image lie with the photographer, art director, or both. A famous UK example was the cover shoot for an Oasis album, which was covertly photographed and leaked to a newspaper. The court ruled in favour of the photographer, upholding the traditional view that the rights of the person pressing the shutter button trump all other rights. But now that UK and European copyright law has moved towards a test of protecting 'intellectual' creation over the technical act of bringing a photograph into being, a similar case might now be decided differently. So if you are taking a photograph of a scene curated by an assistant

or art director, make sure you have paperwork determining who owns the rights and what you can do with the photographs.

Cities are obviously built and paid for by someone. But who do streets, pavements and squares actually belong to?

Ownership of buildings will generally be clear enough: the person who owns the land owns the property, although in many situations, architects retain underlying rights in their design. Attributing concepts of property to civic facilities such as roads and pavements is more complicated, although a simple answer is that – unless the land is private – we the public paid for and own them.

So generally, I can shoot away?

Legal issues with photographing places tend to arise in situations where the latent risk is obvious (i.e. you're photographing a famous work of modern art, or the private pool of a royal princess, or a secret service training facility).

Nevertheless, aggressive policing of rights is not unheard of even where the legal basis is questionable. For example, certain stock image companies cover themselves by forbidding certain types of use for their scenic images, or asking contributors to avoid the use of particular buildings as the focus of a submitted image. This is really a case of sizeable image catalogues, who offer an obvious and wealthy target for rights holders, seeking to minimize all theoretical risks.

Private and journalistic uses of images tend to attract more legal exemptions for photographers (e.g. fair use, called 'fair dealing' in the UK) than public uses for commerical or artistic purposes. The most nakedly

commercial uses – packaging and marketing – are the most open to complaint. But even the most aggressive owners still need some credible basis of legal claim to bring an action to stop you, and by photographing public objects and places you will rarely give them that excuse.

Owen O'Rorke is a specialist in UK media and intellectual property law at Farrer & Co and deals in both contracts and legal complaints from all sides of the Rights debate.

Please note that all cases will be dependent on the facts, and the above does not constitute legal advice, but represents discussion and guidance as to the present state of the law in general terms. Different jurisdictions will apply the law differently. If in doubt, always seek legal advice.

Troubleshooting

What's the best camera for photographing places?

It all depends on what places you want to photograph and how you want to photograph them. The photographers in this book use a range of cameras, from iPhones (Kathy Ryan, p.108), to DSLRs (Floto + Warner, p.39), to large format (Steffi Klenz, p.107). Look back at those examples and you'll see that your camera is both a conceptual and technical choice.

And what about lenses?

Same goes. The lens you use should be right for the subject matter. That said, you always want to strive for the best quality lens. Zoom lenses are more versatile, but prime lenses (those fixed at one focal length) have sharper optics. So perhaps consider buying a range of prime lenses, from short to long, over time.

Why is the depth of field deep, even though I'm using a wide aperture / low f-number?

Chances are you're using a wide-angle lens and focusing on something quite far away. This always results in quite a deep depth of field. Try zooming in or focusing on something closer.

Why is the depth of field shallow, even when I'm using a narrow aperture / high f-number?

This is probably because you're using a telephoto lens or focusing on something quite close. Try zooming out or focusing on something further away.

Why is the sky so burned out?

The sky is almost always brighter than the land, even on overcast days. You've likely taken your exposure reading off the darker landscape meaning you've overexposed the sky. Use Exposure Compensation ⊠ and scroll towards the − to slightly underexpose your image to bring out more detail in the sky.

What is bracketing?

Bracketing allows you to take several shots of the same subject at different exposures, from underexposed through to overexposed. Most DSLRs offer an Auto Exposure Bracketing setting (**AEB**). This is handy when you're shooting a scene with extreme highlights and shadows, like a landscape with sky and land. First, it means that one exposure will be 'correct'. Second, it means you can combine the exposures using image processing software to create a single image with a greater tonal range. This is similar to **HDR**, meaning 'higher dynamic range'. But excessive **HDR** is vomit inducing so please try to keep your image in the realms of reality.

Bracketing vs HDR?

Using your camera's Auto Exposure Bracketing function (**AEB**) will result in several separate images from underexposed to overexposed. You can then combine these files using image processing software so you have an image with a greater range of tones. The **HDR** function on your camera, however, essentially combines these exposures into a single file. This is best avoided as it doesn't give you much control and the result can look very naff.

Why do my landscape photos all seem a bit flat?

All digital files, especially RAW files, need a bit of pumping up with image processing software, so it's normal that your landscapes might look a bit flat straight off the camera. It could also be an issue with the lighting. Were you shooting on an overcast day? Were there very few shadows? Was it quite hazy and you were shooting into the distance?

How can I make my photographs of places feel a little less 'generic'?

Well this can't be answered in a single paragraph, I'm afraid. Have another read of the 'Location' section. You'll see that all the photographers have responded in very distinctive ways to the places they've photographed. They've avoided the obvious shots of famous landmarks and instead drawn our attention to more unusual subjects. Remember, for a photograph to have meaning, you have to marry together the 'what, when, and how'.

Index

Page numbers in **bold** refer to pictures

Credits

p.8 Courtesy Kyler Zeleny; **p.11** J. Paul Getty Museum; **p.12** DANCKAERT, 549 (Hong Kong), 2011, archival pigment print on fine art paper, print 39 x 58 cm, edition 3 © Bert Danckaert. Courtesy Roberto Polo Gallery, Brussels; **p.15** © Tim Hetherington/Magnum Photos; **p.16** © Mitch Epstein/Black River Productions, Ltd. Courtesy of Galerie Thomas Zander, Cologne. Used with permission. All rights reserved; **p.19** Image courtesy of Mitch Dobrowner; **p.20** Courtesy Massimo Vitali; **p.22** Copyright Joel Meryerowitz, Courtesy Howard Greenberg Gallery; **p.24** © Stephen Tourlentes; **p.27** © Lee Friedlander, courtesy Fraenkel Gallery, San Francisco; **p.28** © Yoshinori Mizutani, Rain, 2015, courtesy of IMA gallery; **p.32** Courtesy John Hilliard; **p.35** Simon Norfolk/INSTITUTE; **p.36** Courtesy and © Charles March; **p.39** Floto + Warner; **p.40** Courtesy Olaf Otto Becker; **p.43** Courtesy John Gossage; **p.44** Courtesy Rinko Kawauchi; **p.47** Image © and courtesy Kikuji Kawada/PGI; **pp.48, 50, 51** Icons made by Freepix from flaticon.com; **p.52** © Richard Misrach, courtesy Fraenkel Gallery, San Francisco; **p.55** © Harry Cory Wright; **p.56** © Philippe Chancel / Melanie Rio Gallery; **p.59** courtesy Fraenkel Gallery, San Francisco, © Robert Adams and the Fraenkel Gallery; **p.60** © Harry Gruyaert/Magnum Photos; **p.63** © Alec Soth/Magnum Photos; **p.65** Photo © Centre Pompidou, MNAM-CCI, Dist. RMN-Grand Palais / Jacques Faujour © Estate Brassaï-RMN-Grand Palais; **p.66** Courtesy Rut Blees Luxemburg; **p.69** © Todd Hido; **p.74** Henry Carroll; **p.77** © Richard Mosse, image courtesy of the artist, Jack Shainman Gallery and Galerie Carlier Gebauer.; **p.78** Copyright Dodo Jin Ming, Courtesy Laurence Miller Gallery (image from a dream, 9 March 2000: Within you there is a fire / Within the fire / An expanse of water); **p.81** © Tina Hillier; **p.82** Jorma Puranen, courtesy of Purdy Hicks Gallery; **p.85** Courtesy David Zwirner, New York/London. © DACS 2016; **p.86** J. Paul Getty Museum/Open Content Program; **p.89** © Matt Siber; **p.92** © Mike Slack; **p.95** © Ansel Adams Publishing Rights Trust/CORBIS; **p.96** Anzenberger Gallery http://www.anzenbergergallery.com; **p.99** ©Martin Parr/Magnum Photos; **p.100** © John Davies 1983; **p.103** Fay Godwin/Collections Picture Library; **p.104** © Dillon Marsh; **p.107** © Steffi Klenz; **p.108** Courtesy Kathy Ryan; **p.111** Images courtesy Sonnabend Gallery, New York; **p.113** © Joel Sternfeld; Courtesy of the artist and Luhring Augustine, New York.; **p.114** Courtesy Joan Fontcuberta; **p.117** 'Rio Vista Boulevard' from the series 'Gold Coast, Copyright Ying Ang, 2011; **p.118** Copyright: © National Geographic Creative / Alamy Stock Photo

Acknowledgements

I'd like to say a big thank you to Sara Goldsmith, Peter Kent, Alex Coco, Jo Lightfoot, Eleanor Blatherwick and everyone else at Laurence King who worked on this book. Then there's Luke Butterly (lukebutterly.com.au), Owen O'Rorke (farrer.co.uk), Francesco Solfrini (lefotodifrancesco.com), Joseph Kwaku Sarkodie (sarkodie.com), Christopher Stewart, Esther Teichmann (estherteichmann.com), Caroline Roughley, Ruby Grose (rubygrosedesign.com), Melina Hamilton (melinahamilton.com), Selwyn Leamy (selwynleamy.com) and all of the 50 photographers featured. Thank you!

About the author

Henry Carroll is a photographer, writer and speaker. He is the author of the bestselling book *Read This If You Want To Take Great Photographs* and the co-founder of frui.co.uk, one of the UK's leading providers of photography holidays, courses and events. He has an MA in Photography from the Royal College of Art and his photographic work has been featured in a number of international exhibitions and publications (henrycarroll.co.uk).